4/05

VOICES OF AMERICA

Soulard's
Second Century

WITHDRAWN

VOICES OF AMERICA

Soulard's
Second Century

Compiled by
Betty Pavlige

ARCADIA

Published by Arcadia Publishing,
an imprint of Tempus Publishing, Inc.
3047 N. Lincoln Ave., Suite 410
Chicago, IL 60657

Printed in Great Britain.

Library of Congress Catalog Card Number: 2001087369

For all general information contact Arcadia Publishing at:
Telephone 843-853-2070
Fax 843-853-0044
E-Mail sales@arcadiapublishing.com

For customer service and orders:
Toll-Free 1-888-313-2665

Visit us on the internet at http://www.arcadiapublishing.com

This book is dedicated to The Holy Trinity

Father-Son-Holy Spirit

CONTENTS

FOREWORD

The most profound values in life are to be kept in the proper perspective of a simple form; to love God and the rule, and be aware of the needs of others and everything living. Every effort no matter how small is important.

I read somewhere that one of the most important things to us is our memory. Early memories are beyond our control, but fortunately childhood play has a way of being lifted above bad conditions into the joy of the creative world.

I remember one summer day, my friend and I pulverizing small pieces of bricks into a powder and laying the powders on a board and comparing them for the sheer joy of color—leaving us with the lasting memory that all bricks are not the same color.

This book is a variation of happenings over a long period of time that left memories strong enough to write about.

Thanks go to Diane Schnalzer, for inspiring the title, and Sister Dionysia Brockland, S.S.N.D., for granting us use of the doctor William Swekosky photograph collection. Special Thanks to Terrence Hall.

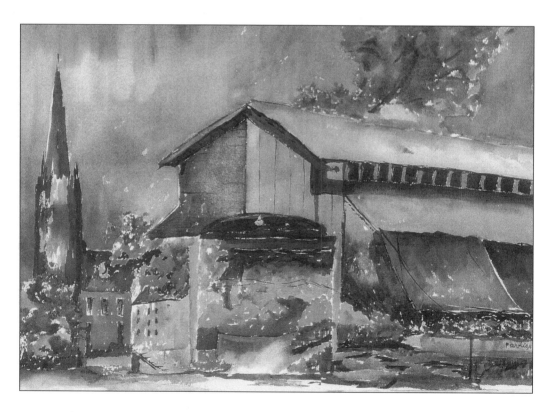

Water color painting of Soulard Market, by Betty Pavlige.

INTRODUCTION

The city of St. Louis came into existence near the Arch and river front, mostly because river traffic was the easiest mode of travel for travelers and heavy objects, and the landing was clear.

Trading posts were quickly established with shipped-in supplies—including barrels of whiskey with unheard-of constrict ions as to the sale or consumption, therefore creating much lawlessness fighting and a bad atmosphere for families trying to settle near by.

A very affluent French family arrived, but decided to settle farther south naming their settlement Soulard. Other families quickly followed.

The most affordable housing was quickly started in the form of four apartments to a building with three rooms each. The buildings with various owners were close to one another, separated by a brick hallway commonly called a gangway.

It was common practice for the owner of each building to copy the architecture from their home country, thus many styles of architecture are evident in Soulard, even

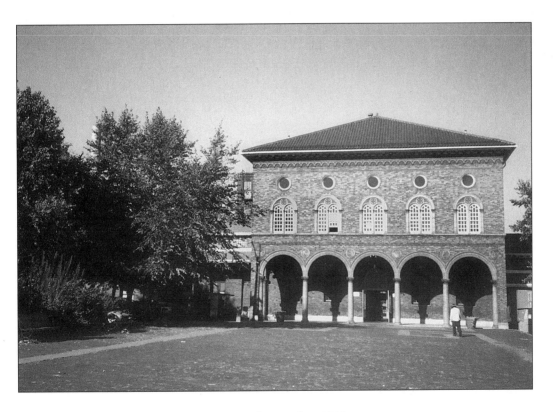

Soulard Market, southern brick promenade, October 2000.

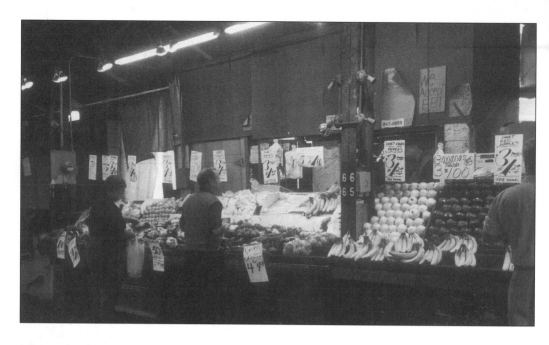

The Soulard Market.

Gangways between buildings in Soulard.

today, like German, French, etc.

The civic minded Soulard family saw to the community needs and quickly established Soulard Market, plus other civic needs such as streets, sidewalks, etc.

Soulard was in a rapid growth of immigrants from various countries: Germans, Russians, Polish, French, Irish, etc.

It was common practice for the men to come first, find work and save their money, to send for the rest of the family which sometimes took two to three years until they had saved enough of their meager earnings for the passage.

Unfortunately history hasn't given the proper credit to those men who had actually made terrible sacrifices to accomplish the move. It took a lot of courage to leave their families—go far away to a strange place often working long hours, sometimes sharing one room with two or more men in the same predicament counting the weeks, and their savings.

Finally, the wait would be over and their families would start to arrive—each family

trying to settle near someone of their own nationality, creating a little community of their own.

The new Americans were spiritual people, putting the establishment of churches ahead of their own needs-building churches that would last for decades- even centuries-like the St. Peter Paul church on 8th and Allen.

They also brought with them the festive Christmas tradition from Europe, plus recipes of their particular traditional dishes.

The families were usually large. The mother seldom worked outside the home, so actually she was the dominant force in the household, centering in the kitchen.

She prepared food daily for the family. She shopped for meat or milk from the small corner grocery store, and relied on Soulard Market and the farmers for produce which included live chickens that she would take home, kill, and clean.

Going to Soulard Market was a necessary Saturday ritual. The mother, with her big basket on her arm, and the oldest children with a smaller basket on their arm would all walk—sometimes a long distance—to get there.

Bargaining with the vendors was part of the venture, actually both enjoying the encounter as a partly-social partly-business weekly affair embarrassing her children—especially the boys—to the extent they would step back and try to blend in with the crowd, so that no one would suspect they were with her.

Shopping over, the long walk home would begin. The mother would lead the way meeting friends along the way, stopping proudly, displaying her bargain of the big fat squawking hen in her basket that she had paid 35¢ for—the hen who would be chicken soup and home-made noodles as part of her Sunday dinner. It was usually accompanied by a roast and home made bread if the family was large.

Sunday in early Soulard was held in this strict ritual of the Christian faith that it was a Holy Day. Thus, big families dressed in their

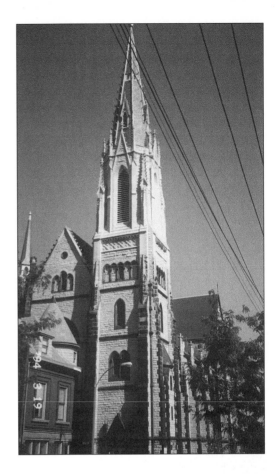

Front view of St. Peter and St. Paul Catholic Church.

best would proudly walk to church, the mother and father leading the clan glad to be Americans, glad to have a job, home, food, and the church.

Sunday afternoon and evening was a time for food, visiting relatives and friends, or go visiting yourself.

Since there was no radio, TV, and few cars, you looked for fun and joy with others in a quiet, low-key life.

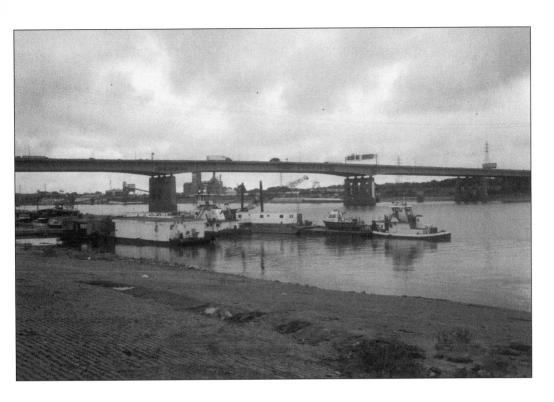

St. Louis Riverfront.

EARLY LIFE IN SOULARD

The fear of death was always prominent in our thoughts. We grew up with the awareness that for a really serious illness, there was little to be done. Our low standard of living made the barest minimum of medical care usually beyond reach, and for disorders and accidental injuries that failed to improve with home remedies, we learned to wait hopefully, knowing that life was tenuous, that its end came with absolute finality, and that we should never push our luck too far.

The stern facts of life had a strong influence on our oral standards, and on the code of ethics that we lived by—or violated—with terrible feelings of risk. Dependability was a high virtue, and we regarded a lie, even a little white lie, as one of serious offenses. For one thing, in the crisis situations that often came on fast, it could be dangerous not to know the true facts, the conditions that we had to deal with as best we could with whatever experience we had. The lie even became a kind of allegory of death because it submerged truth, covered it over, and contaminated it. This was taught in our homes, and it was reinforced by consensus among the children wherever we gathered to play—the schoolyard, the streets, or the river.

Almost everything we did was by way of routes along our streets and sidewalks, so we knew them well. There were few perils in this everyday passage. We could move freely anywhere. Watching for moving vehicles was second nature, and if any person looked like someone we wouldn't want to encounter, we could just cross the street. Our beloved river, just a couple of blocks away, was a constant attraction, but it was different. We knew that it could turn on us. I don't suppose we were as careful as we should have been when we wandered down to the river to play along the bank, or to swim near the shore, but our natural instincts were wary.

Usually we swam within the narrow

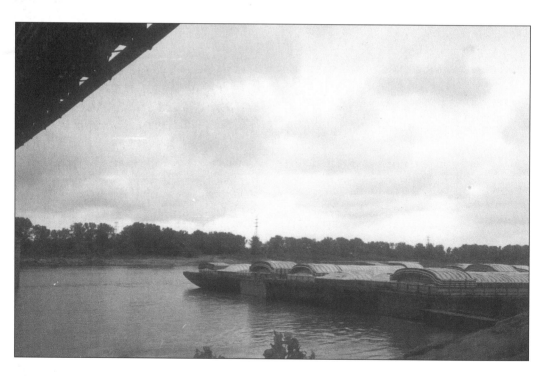

Barges on the Mississippi River.

stretch of water between the shoreline and the barges that were anchored there to be filled, or to be picked up by a towboat. The barges slowed the surface currents, but the stream swirled underneath them in powerful eddies and crosscurrents. A swimmer caught in this treacherous undertow didn't have a chance. We knew of the danger, but underestimated it.

Another danger to which we never gave a thought was the raw sewage that came pouring into the river from the big mains upstream from us, and became a part of the water in which we played.

One summer afternoon, a group of boys went swimming in the river. A gangplank between the bank and one of the barges served as a platform for jumping and diving near the end farthest from the barge—but not far enough. A blond boy dove off it, but didn't come up. The barge was very wide, and very long; too big for a swimmer pulled underneath it to come out quickly.

The police and fire departments were summoned, and so were his parents. The father, at work, couldn't be reached quickly, so the boy's mother stood alone on the riverbank, stunned and terror-stricken.

A large group gathered to watch the attempts at rescue. Everyone was quiet. It was almost like holding our breath, as if breathing was an offense, since we had the freedom to do so and the boy didn't.

Every second that passed decreased his chances of being found alive. The men used grappling hooks on long handles, reaching as far as possible under the barge. No one talked or moved, the only sound being the hooks going in or coming out of the water as the men waded along the side of the barge. Time was running out, and the men worked frantically. The mother, hands over her face, moaned, almost rhythmically.

The time was out. It had to be faced. After 10 to 15 minutes, he couldn't possibly be alive. Two friends of the mother, having just heard the news, came running toward her, throwing their arms around her, and crying uncontrollably in consolation.

Despite the time, the rescue work went on steadily for a half-hour or more. We realized that he might have drifted out from under the barge. The two friends of the mother were calmer now, and were using a different tactic of consolation by assuring her that drowning was the easiest of deaths. Everyone said that, they told her.

Then all the onlookers became tense again. The hook had caught on something under the barge, and it was slowly being pulled out, very carefully so as not to lose it off the hook A piece of cloth was the first thing we saw. It was the boy. They pulled slowly and steadily. He was face up, his blond hair spread softly in the muddy water, and on his face a look of such pain as to contradict for all time the belief that drowning is an easy death.

Rehabilitation work being done at mid-19th century buildings in Soulard.

It was common practice in Soulard to lay the dead out at home, right in the living room, and to maintain a round-the-clock vigil, sometimes for days, while awaiting out-of-town relatives who might have to travel a considerable distance by bus or train. Neighbors were usually solicited to sit for intervals of two or three hours. The depressing and unnerving hours, avoided by many, taken by a group of men, who fortified themselves with homemade wine or home brew until others took over the mourning duty.

The public announcement that a member of the family had died was made by hanging a funeral wreath on the front door, sometimes with a flowing black ribbon. A funeral from the home provided a shivery kind of excitement for the neighborhood children, especially those who had only a remote acquaintance with the deceased.

Gangways between buildings in Soulard.

Their reputation for bravery among their peers was gauged by their having the courage to go in and look at the dead person. They would go in solemnly, trying to look as bereaved as possible to fit the occasion. Then they would return outside to greet other friends, less courageous, and release tight emotions from the strain of looking at the dead, by running up and down the sidewalk in complete abandon.

But the mourning rituals for the boy had a different effect. He had been one of us, and his death was caused by doing what we all had enjoyed doing, often. The young body laid out at his house could have been one of us, for we had taken the same risks. It was a painfully sobering loss to us, and I felt that I couldn't possibly go to his home and see his face again.

My mother volunteered to sit at the home for the evening, and my sister went along for support. I was asleep when they returned. I woke up, startled, to look into Lona's face, close to mine, looking at me intently in the bright light that she had turned on. She said, "I just wanted to see if you were alive. I don't want to go to bed with a dead person."

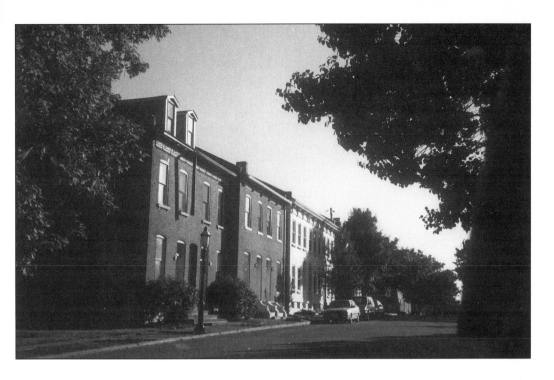

Old coach lamps still light many of Soulard's streets.

THE LOST BOY

At dusk one hot summer night, his mother couldn't find a five-year-old blond-haired boy, who lived near us. Everybody joined in a frantic search. They reasoned that it couldn't be a kidnapping for ransom—a familiar threat to children of rich families in those days—because there was no money in this family. Finally, the police were called. They searched up and down the streets, alleys, the banks of the river, everywhere, asking everyone if they had seen a boy of his description. His young parents were disconsolate.

The hours dragged on. The neighbors milled around on the sidewalk, sharing the young couple's concern, giving sympathy and strength by just being with them. Midnight came and no one went inside, even though the next day was a workday for many. They brought out chairs, sat close together, surrounding the young couple, talking quietly, waiting, just waiting. There was nothing else to do. There was strength in unity as a group, and no one dared to leave. The hot night cooled off, a slight breeze came up, and the air was pleasant on the sidewalk. We sat quietly on the edge of the sidewalk, our feet in the gutter. We knew loud talk would be offensive. We sat and listened to the low conversation of the group, barely audible to us.

There was nothing to do but look up at the stars, or at the street light that shone down on the crabgrass across the street, and wait—for whatever might be. The night dragged on.

The tall, late summer crabgrass grew thick on the edge of the sandlot across the street, and was going to seed. The stems of the grass, with the seedpods on top, swayed in the breeze. The swaying movement was pleasant and relaxing to watch and made us sleepy. We weren't used to being up this late. Even the mosquitoes were gone. The group sat quietly, the young man with his arms around his wife, who cried softly.

Suddenly, at about 2 a.m., there was a movement in the crabgrass. A blond head popped up. It was the boy. He had been lying down asleep in the cool weeds for hours, and now his sleep out, he got to his feet, and came toward home. Nobody had thought of looking for him in the crabgrass.

His father ran to him, swooped him high up in the air in the joy of the release from such a worry. Everyone was laughing and talking at once. They took turns holding the boy, passing him to each other. The boy didn't know he was lost, and was awed by all the attention. No reprimand was given. He had been innocently asleep, trying to escape the heat, searching for comfort in the cool crabgrass. The group disbanded and went to bed, their ordeal thankfully over.

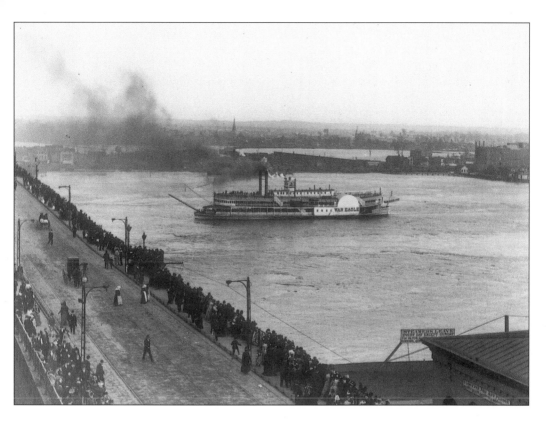

A flood on the Mississippi River in 1893 looking toward Illinois on Eads Bridge in Downtown St. Louis.

LIFE IN SOULARD

Life in Soulard was strictly in terms of what that section of the city had to offer. Sidewalks were a big part of our lives; their curbside edge a front-row seat for watching the movement of our world. People walked back and forth to employment, to go home for lunch. Everyone walked everywhere, mostly, unless their work or other destination was too great a distance. Then they relied on the streetcar.

There was always someone coming or going on the sidewalk in front of our house. It was like a main thoroughfare. There wasn't much chance of communion with nature if that was what you wanted because there were no trees close by. My mother's battle with the cinders to force her zinnias and morning glories to survive provided the only

Pen-ink-watercolor of sand piles on the Mississippi River banks by Betty Pavlige.

living color in our vicinity, and the next available level of horticulture was the crabgrass.

But we really didn't need trees, grass, or flowers because we had an unrivaled work of nature that absorbed our attention and stimulated our imagination above all else, the great, muddy Mississippi River. Its course past St. Louis took it within a few blocks of our homes, and it was there, day and night, through all seasons, a majestic and alluring spectacle. We spent a lot of summertime hours in the river and along its bank.

Among attractions of the bank were man-made hills of sand, dragged from the river and built up in towering storage piles. There was a watchman who could be very disagreeable about kids climbing up on the sand piles. They had accepted him simply as a fulfillment of the classical role of watchman to block the access of kids to forbidden delights. So we played the classical role of kids, to get past the watchman, one way or another.

We were sure that he had never taken the time or trouble to climb to the top of that enormous sand pile and just stand there appreciating it as a spiritual experience, or he would have been glad to share the summit with us. The summit was so high that everything below became dwarfed, and you were in a world other than the one far below at ground level. With the muted distant noise and the wind blowing on you, the same wind that had been blowing on someone else, somewhere, far away, maybe in China. That moment was worth the hard climb plus the fear of the watchman, who at some time might become more than disagreeable.

You stood absorbing everything in the short span of time you dared stand in that exalted place, the view toward the Eads Bridge that spanned the river between St. Louis, Missouri, and the city on the other side, East St. Louis, Illinois, the turn in the river clearly visible even further up north, fading to a grayish blue atmosphere. Nothing we ever did could possibly compare with this, time cut too short

by an arm-waving, threatening figure far below, to lay down and roll over and over and over, all the way down, arriving at the bottom so dizzy we could hardly stand and trying to run as fast as possible on wobbly legs to put a distance between us and the watchman for the time being.

Our experience was well worth the chance we took until something happened that caused us to decide of our own free will never to go up the sand pile again.

There was one luxury that few cared to dispense with for economy's sake, the newspapers, the *St. Louis Post Dispatch* or the *Star Times*. My mother bought the *Post*, when possible. One day the paper had a startling article, with pictures. A boy had been climbing on the sand pile and for some reason had sunk deep into the sand and was smothered. The fire department was called and dug him out, but too late. It was a shocking fact to us, taking away all desire to climb the sand pile, no matter what marvelous emotions we experienced at the top.

I sat quietly as my mother read aloud every word of the article. Then, laying the paper aside, she said, "That's too bad, but of course some people just never seem to know at all what their kids are doing."

There was another exciting facet to the riverbank: empty boxcars, switched to a sidetrack to be cleaned out on this switch track by workmen. The contents were dumped out on the ground in a hurry to make the car ready for the next trip.

One summer day, as we walked towards the switch track, we noticed a large pile of something white that had just been thrown from a car. The workmen, their job finished, walked away. We ran toward the pile, white with orange flecks. What could it possibly be? We were amazed to find that it was a pile of crushed ice and that the orange flecks were carrots, possibly loose from crushed shipping containers. Carrots were an unusual commodity in my home.

We dug through the ice searching for the gems, eating as we scooped hard, crispy,

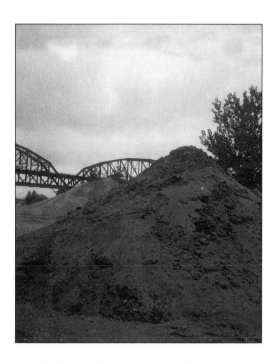

Sand piles at the Mississippi River.

Sand piles at the Mississippi River.

19

Some of the cars carried coal, loose pieces, falling to the ground as the cars jostled along. Everyone heated their homes with coal, so the loose pieces were valuable and were picked up and stored away in basements, until needed in winter. We never bothered with the coal, not having the foresight "to think of another winter coming." We were interested in only what was available to eat at that minute.

Crossing-man" yells warning to those crossing train tracks just west of Soulard, in this undated photograph.

juicy carrots. We could find no container to carry our prizes home in so we used the only available thing, the laps of our dresses, filling them so only when we walked, the front of our cotton pants were clearly visible to anyone coming toward us. We had a choice: our pride or the carrots. We chose the carrots, ignoring and not offering to share even one of our valuable cargo with any of the laughing, taunting boys we met.

Some of the box cars carried grain, wheat, corn, and oats, remnants swept out on the ground forming neat little piles which we scooped up with our hands and ate until satisfied, chewing the hard fiber until it formed a satisfying flavor to our taste buds, not taking any home because we couldn't possibly think of any use for it except chewing it there.

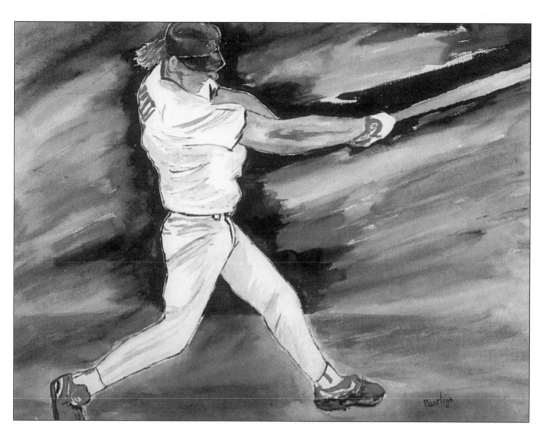

Watercolor painting of a "Synchronization of Swing" by Betty Pavlige.

SHUTOUT AT SECOND
AND VICTOR

The St. Louis Cardinals lack one home supporter—me. My lack of interest in the ups and downs of St. Louis's great baseball team is absolute, and it has been referred to as some kind of personality defect. It isn't that I have anything against the Cardinals. It's just that I don't feel uplifted when they win, or downcast when they lose. It is baseball itself that arouses my apathy, baseball as a competition that calls upon its spectators to identify themselves as for one team against the other. I haven't always been this way. The condition dates from a time in my early teens when I cheered very hard for a baseball team because it was very important to me that it win. My team did not win, and consequently at this impressionable time of my life, I suffered an irreparable disappointment. So I never again let myself become emotionally involved with the outcome of a baseball game.

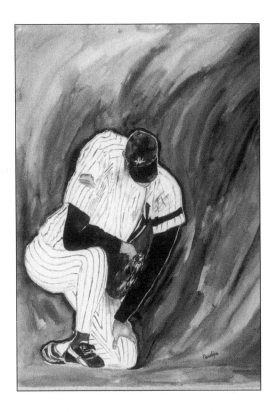

Water color painting of a "losing player" by Betty Pavlige.

What was riding on this game was a ticket to the Shenandoah for Helen, my best friend. The Shenandoah was a movie theater at Broadway and Shenandoah Avenue. Helen and I basically lived for an occasional Sunday evening at the movies there. Nothing else that we did came close to that enjoyment, but the price of admission wasn't easy to raise, because the country was having that long Depression that is remembered with such pangs by those who lived through it.

Helen and I had only two possibilities for the admission. Mine was my older sister, Lona, one of the elite—the employed. When Lona could spare the 25¢, my ticket was assured. Helen's prospects were more complicated. She and her two slightly older brothers were motherless, and she did their laundry, rubbing the heavy jeans and shirts on a washboard in a round zinc tub of water as hot as her hands could stand. She often had blisters on her knuckles.

Her brothers played baseball on a lot at the northwest corner of Second and Victor Streets, across the street from our house. There were houses on part of this block, but the corner had been vacant as long as anybody could remember, and the neighborhood boys played ball there, for money. The players would chip in to make up a pot, and the winning team got the pot to divide among its players. When Helen's brothers' team won, her payment for their laundry came from their share of the pot. When they lost the game, the laundry was her donation and I had no partner for the show.

The neighborhood boys, about 25 early teenagers, were also victims of the Depression—no jobs, no money, nothing to do in summer but sit on the corner playing cards, talking, and watching the girls go by. The girls always crossed the street to avoid walking through the group.

Practice makes perfect as much in card games as anything else. In later war years, one of the boys became quite wealthy after he was inducted into the service, went

overseas, and put in his spare hours in card games. He won large sums of money, which he dutifully sent home to his mother, who immediately invested it in real estate at the right time, insuring prosperity for the next couple of generations for their family. So sitting on the corner playing cards wasn't exactly a waste of time for Mickey.

The boys spent a lot of time practicing baseball in preparation for their big game with the teams from other neighborhoods, with a pot to stimulate their urge to win. These Sunday games on the dusty corner lot became the crucial links in the prize of a movie with me that evening, or of staying home for both of us since I couldn't go alone.

On the day that turned me off of baseball forever, we sat on the edge of the sidewalk in the hot sun, our feet in the gutter watching every move on the field like professional critics. We knew who could hit and who couldn't. We knew who were the good runners and the poor runners, and the dependable fielders. Most importantly, we knew who worked at it, who put forth the supreme effort. We passionately wished the visiting team the worst of everything because the highlights of our social life depended on the triumph of our team and the humiliation of the opponents. The boys probably thought they had two ardent admirers, sitting on the sidewalk with rapt attention to their every move. On the other hand, their extrasensory perception might have caught the intensity of our real motive for cheering for victory for our side, and of our fury when our side lost, because in later years I don't remember any of them asking either of us for a date.

Anyway, on this hot, summer Sunday, there we were in our usual place, I with the price of admission in my pocket, but Helen's chances depending on her brother's team winning the game so they could pay her for the laundry. The Shenandoah had a movie that we especially wanted to see.

As far as we were concerned, the stakes were high.

Our sidewalk seats were a long way from any shade, and the concrete absorbed the heat, then threw it up in waves around us. We sat, even through the home team's warm-up period. Helen's older brother was in the lineup. We sensed that the boys were unusually loud and jumpy.

The rival team arrived, with a large group of girls who carried blankets and placed them on the grass to sit on at the edge of the lot. Both teams were warming up for a longer time than usual. We wondered about the delay, and then, walking toward us, slowly coming down Second Street, a lone figure—a tall, dark, unusually handsome youth with dark pants and a snowy-white shirt, open at the throat and the long sleeves turned up twice, neatly. Uniforms on sandlot teams were unheard of, but white shirts were even more unheard of. He walked slowly and seemingly unconcerned to the edge of the field. His teammates crowded around him, talking excitedly, and collected from him his share of the money for the pot, the winning team to take all. He was their pitcher. He smiled, but said nothing, and then deliberately faced the girls, and smiled again. It didn't take much to see who the girls came to watch. They never took their eyes off him and he basked in their adulation. He projected supreme confidence, and still said nothing.

Helen and I were fully impressed with his beauty and his confidence. We had never seen anyone like him outside the Shenandoah. But we were more concerned with his ability, because he was tampering with the price of Helen's show ticket. At that point we felt secure in our reasoning that his slowness indicated a lazy spirit, so he seemed unlikely to be much of a threat.

Following sandlot protocol, the guests were the first up, and showed no more ability than our own team. Then our team was up to bat.

Their pitcher walked slowly to the mound in his open-necked white shirt. He stooped to pick up a touch of sand, then threw a couple of slow balls to the catcher. He had

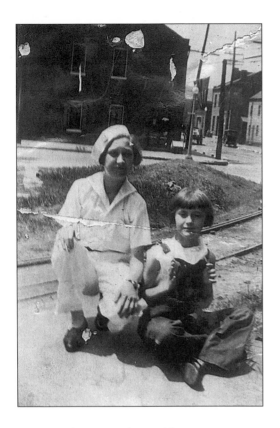

Betty Pavlige on right, and her sister Lona.

missed the warm-up period by being late. He motioned that he was ready.

Our first batter came up. The pitcher stooped for the touch of sand, wound up slowly, and threw the ball. Strike one. Helen and I both automatically stood up. We had never seen such strength, such speed. Well, maybe just a good throw. He wound up slowly, then strike two, then three, and out. The second batter came up and took a determined stance. The pitcher wound up slowly again. Strike one, two, three, out. The performance continued through the third batter. The sides changed, and our team held a council. They formed a circle, heads down, quietly talking. They were worried.

The guests were at bat, and got a hit, then two. Then the pitcher was up. He got a longer hit, bringing in the two runners, himself landing on third. As he ran we noticed he was slightly bowlegged. We joyously discussed this defect, and stood up to scream it to the world, provoking the ranks of the female gallery to the extent that we immediately sat down and shut up. They were older, and they meant business.

The third inning came up, that pitcher on the mound again. His shirt was glaringly white in the bright sun, and spotless, the twice-turned-up cuffs still neatly in place—all in order. He stopped to barely touch the sand and carefully rubbed it on the ball. It suddenly struck me that he seemed even more concerned with not soiling his clothes than with the game. It was years later, after he had become my brother-in-law, that I learned he didn't dare go home with soiled clothes and reveal to his mother that he had been playing ball on Sunday.

Helen's brother came to bat, and to our dismay, struck out, as were his two followers. The fourth inning came up, then the fifth, and he hadn't allowed our team a hit. The crowd around the field became very quiet. The unbelievable could happen for the first time on the sandlot: a no-hit game. The seventh and eighth innings passed with no hits allowed, and the last of the ninth came up.

He went to the mound, stopped for his touch of sand and motioned that he was ready. He wound up slowly, and threw the ball. It hadn't lost its speed, his strength was still there. Strike one, two, then three—out. The crowd was almost rigid as the second batter came up—one, two, three, out. For the third and last batter, he stood for a second, went through the slow windup and threw the same three strikes. He had pitched a no-hit game.

The crowd was ecstatic, his female gallery jumping and screaming. He smiled, took out a white handkerchief and wiped his brow. The money was divided among the winning visitors. He collected his part and started walking along Second Street, in the direction he had come from, Helen's price of the show in his pocket.

The Orange Soda Factory, Smile Company, in the heart of Soulard.

THE WAREHOUSE FIRE

One extremely hot summer night, my sister and I took our quilts and went to our hard bed on the back yard cement. It was a hard bed, but had its advantages. You could lie on your back and look at the stars all night, if you wanted to, and wonder why they were there, for what purpose, how far away, why everything, not expecting an answer, but it was nice to wonder.

The cool breeze was soothing, the city noises dulled and faded away as I drifted off to sleep, only to be awakened by mother standing over us saying, "Get up, get up, Lordy, Lordy, there's a big fire someplace and I can't see anything." She had reverted back to her Southern accent, which she automatically did in a crisis. Her Southern accent was like a battle cry to us. We jumped up, grabbed our quilts and ran inside, then stood there. The excitement was outside. We ran out again.

My mother stood amidst the smoke drifting, "Lordy, Lordy, I'll bet somebody is being burned up alive as she watched the flames jumping high in the air from something burning not too far away.

The neighbors were alerted too, and came running out of their homes in the direction of the fire. My sister said, "Let's go too, Mama, hurry, let's go." My mother hesitated, looked at me and said, "You stay here," which I had every intention of doing anyway. I had taken her comment of someone burning up alive as a fact, and I didn't feel quite up to the ordeal, preferring to sit on the edge of the cement detached from it all.

The flames went higher and higher, throwing an eerie red light over everything and erasing the sense of familiarity. I sat, my back-side glued to the cement, afraid to go into the house, and afraid to sit there, my imagination going full blast about a man burning alive.

Finally, the flames dimmed and the smoke lessened. The back yard looked like itself again, and my mother and sister returned. I ran to meet them and said, "Did you see him burning alive?" My mother looked at me questioningly and said, "Who?"

The next morning we were up early. There was much excitement in the neighborhood. The fire had been in a warehouse, almost destroying the building but leaving some of its contents in usable condition. Everyone was going there and searching through the rubble for anything salvageable. They took buckets, baskets, little wagons, anything to carry their selections.

Everyone went but us. My mother didn't think it was a good idea. We might all get in trouble some way. My sister begged and argued with her to go but the answer was, "No!" so we all three stood on the sidewalk and watched everyone coming home, joyfully showing their fire merchandise to each other, and to us.

One man was carrying two cases of bottles. He set them down on the sidewalk to call to my mother, taking a bottle out and showing her. It was Listerine, a mouthwash. He unscrewed the cap and she smelled the bottle and complimented him on getting something so valuable for nothing. I asked him if I could smell it. He bent down and held the bottle to my nose. I took a deep breath and the alcohol caused my eyes to water and my throat to burn. I had never heard of Listerine, and was amazed that anyone would dare put it in their mouth, and for what reason, and couldn't see why the man had gone to so much trouble for it, but luckily, I didn't voice my opinion. He picked up his boxes and walked happily down the street.

A middle-aged man was pulling a small wagon toward us on which was perched a large, pasteboard box. He pulled the wagon easily, not seeming to have a heavy load in the box.

He stopped to talk to my mother and jubilantly explained his choice of loot: "If I ever get hurt sometime, I'll sure have a bandage to last me the rest of my life." My mother just stood looking at him.

He walked away, pulling his wagon with the large box which had' big, black letters on the back, "Kotex."

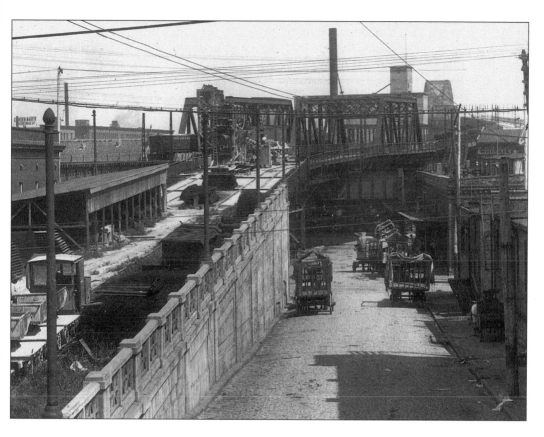

The Free Bridge (now McArthur Bridge) is seen under construction over the Mississippi River, in 1919.

THE MISSISSIPPI

The Mississippi River, called the Mighty, the Majestic Mississippi. It was like something alive, actually a big part of our lives, relieving our boredom because the river was never boring. It cost nothing to walk to the river, to stand and look at the muddy, flowing water, never the same, always moving, going some place, and leaving us behind, standing on the bank.

This walk to the river was part of our social life. We met all of our friends there and walked together along its bank. The St. Louis bank of the Mississippi, directly down from Soulard, had developed a scar. It was a shantytown called Hooverville, named after the President of the United States. President Hoover was blamed for the Depression, ignoring the fact Congress helped run the country, and that other countries were having a depression too. This blame was so

McArthur Bridge.

strong in us that not long ago, shopping with my older sister, I angrily reproached her for buying a rosebush named "Hoover." Then we both burst out laughing at the absurdity of it. We had matured after 40 years.

Hooverville. Some of the homeless, unemployed, having no place else to go, built small shacks or hovels on the river bank out of scraps of any material available. There was a long line of these makeshift shelters stretching along a strip at the river's edge and the railroad tracks. Some of the more enterprising occupants gathered the branches of the willow trees that grew in the mud in some places near the water, and fashioned all sorts of things out of them— planters, child-sized rocking chairs, anything that could be sold for any small amount of money to provide food, because at that time there was no welfare program.

The river provided adventure, too. There was a ferry, charging 15¢ to go to the Illinois side on Sunday for swimming, which was worth the money if you had it, because of the long, sandy beach on that side that stretched for miles. The channel was farther away from that side, allowing a margin of shallow water for swimming without having to work against the strong current of the channel, which was experienced closer in on the St. Louis side.

Despite the low charge of 15¢ for the ferry ride, we didn't go over to Illinois very often, mainly because we didn't have the 15¢. But when we did, it was worth the money.

One hot summer day, we decided to go, four of us. Two of the girls were twins and spoke fluent Polish, which proved an advantage to us before the day was over. We wore our one-piece swimming suits under our dresses, out of necessity, there was no place to change on the beach. We stood on the bank, waiting for the ferry. A large group gathered, some neighborhood boys, all of us in our early teens. Excitement ran high. This was a real outing for all.

In due time we were all deposited on the beach on the Illinois side, the neighborhood boys running up an incline and disappearing

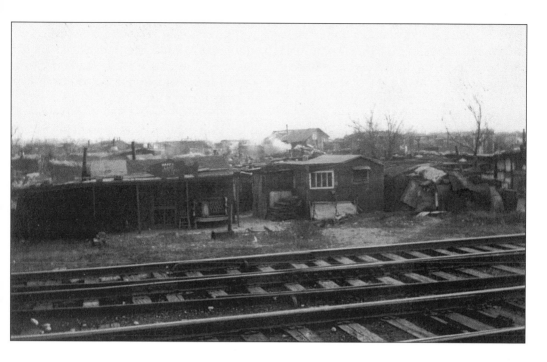

This is St. Louis's version of the shantytowns known as "Hooverville," named after the U.S. President who failed to end the Great Depression. The image, taken from along the St. Louis waterfront, is from c. 1932.

in the willows toward, so we had heard, a place called, "a home-brew joint," which served homemade beer to all, regardless of age.

We had come to swim, but first we walked down the beach toward a man sitting alone, fishing. He had a large homemade net fashioned like a dipper, with a long handle attached to a stand of some sort, on the beach. He would dip the net in the water and, after a short time, would raise it, and hope he had caught a fish. Just as we arrived, he caught one, a fish called a gar. It had a long, snout, with vicious-looking teeth. It fought wildly. He dumped it out on the beach to avoid destruction of his net. He stood back and watched it thrashing around, until finally, it lay quiet. The fisherman came over and, using a stick to force its mouth open, showed us its teeth. I stood looking at the gar, my enthusiasm for swimming dimmed by the prospect the gar had a partner out in the water waiting for him to

come back, or me to come in. The twins decided that we might as well risk the gars. We walked to the landing place, took our dresses and shoes off, piled them neatly on the sand, and entered the water.

There was more mud than water. We sank deep. I wondered if the next step would be on the back of the gar's partner, but it didn't seem to worry the others. I followed on and on in mud. We had gone a long distance, just walking, when suddenly we were in it, the channel, the challenge we came for.

The twins were older, stronger swimmers, and the leaders. They yelled back, "Let's go on over, it's not that far." I knew and they knew that the only way would be to swim toward the other side with the current, and probably end up at Jefferson Barracks, miles from home and no money. But I was no protester, I was a follower. On and on we went, farther south. We were in the center of the river and then one said, "We better go

back—we forgot our clothes." We turned back with the current, still going south, and after some time hit mud again to start the mud walk back to the beach.

When we finally got on our beach we still had a very long trek to make back to our clothes. As we neared the landing place, and our clothes, we heard loud yelling and other sounds of confusion. The neighborhood boys were drunk on homebrew, and fighting. As we walked by the big fight I turned my head, and looked across the river toward a peaceful scene, determined never to get involved with a person who got drunk.

The day went quickly, and the ferry came just before dark, and we all piled on, sunburned and muddy. Our battered, battle weary neighborhood boys sat quietly, scratched, bruised and with indications of oncoming black eyes. They had their 15¢ worth.

As we walked off the ferry ramp, the twins had a suggestion. They wanted to visit a friend in one of the shacks, a man their father had previously worked with, now unemployed and living alone in Hooverville. The four of us walked to his place. He was in his back yard at the edge of the water with a fire going, baking corn on the cob. He spoke only Polish, and the twins carried on an easy conversation with him, which I couldn't understand. Then he generously offered each of us an ear of baked corn, our first food since early morning. We ate ravenously, not thinking that it might have been all the food he had.

By then it was dark, and the moon was out, clear, full moon. The river was smooth as glass, strong and silent, hardly a ripple on the water. The soft breeze cooled my sunburn and I felt at peace with the world.

It was all quickly changed. I sat up, alerted, because the twins were excited, the Polish conversation had picked up tempo. They looked at us and said, "He said we can borrow his boat, and take a ride." I looked down at the boat. It was a homemade rowboat, generously tarred and very crude looking, but it was a boat.

I couldn't believe our good fortune. Such generosity to strangers, and not a word of English. We piled in the boat and shoved off, with what probably were precautionary words in Polish from the owner about his boat.

The twins rowed, the other girl and I occupying opposite ends of our new way to travel on the river without paying. We started up the river, after many preliminary starts and stops, while they got used to t he oars so as to make the boat move. We all agreed this was the best stroke of luck ever. The full moon gave all the light we needed on the tranquil water, and we were moving up, up, past the Free Bridge, later renamed the McArthur Bridge. The twins decided that was far enough, and we could just float back with the current. We were floating toward one of the pilings. We hadn't anticipated the turbulence of the current around the piling. The boat was flung around, almost upsetting us, then a crosscurrent began to carry it out to the center of the river, toward the Illinois side. The twins started to row furiously, fighting for control. We were in the channel, then out, then somehow we were near the Cahokia electric generating plant, where the water boiled out, making it even harder to row.

The twins stopped rowing. They understood this river, they'd cope with this problem. They sat quietly, drifting with the current back into the channel, then using the oars slowly, firmly, edging back toward the St. Louis side, the same way you would swim the river. We finally were out of the channel, but way south again. There was no walking back this time. We had the boat and it had to be rowed back. Slowly, staying as near the edge of the bank as possible for easier rowing, we made it back.

The Polish man was waiting for us at the edge of the water, in his back yard, a big smile on his face, and gesturing that all was well with his boat.

The twins stood looking at their hands, masses of blisters. A sadness came over me because I suddenly realized that I hadn't taken my turn at the oars.

Watercolor of Soulard Neighborhood by Betty Pavlige.

CHARLES A. LINDBERG

One man had put the city of St. Louis, Missouri, into the world news—Charles A. Lindberg. He had performed the amazing feat of flying from St. Louis to Europe, over the ocean in a small one-engine airplane, piloting the plane and doing the navigating mentally.

My older sister, Lona, and her girlfriends were caught up in the excitement. The trip over, he was back in St. Louis, and would fly over the riverfront for all to see on a certain day and time.

They made plans to go. I decided I would go too. We walked down to the river and north along the riverfront. I walked behind, enjoying the walk along my favorite place—the river—not too impressed with seeing the Lindberg plane.

They laughed among themselves. He had won the grand prize $25,000, a fortune, and he was handsome and single. Teenage talk. I walked along thinking to myself how hopeless; he is up in an airplane and you are on the ground.

We came to Chateau Avenue and the free bridge. There were small clusters of people here and there. We stopped near them and waited. Soon we heard the motor of a plane and a small silver plane flew over, the words on the side clearly spelling out "Spirit of St. Louis." It passed, came back pretty high up, passed again, and was gone. We waited heard a motor. He was coming back. This time he came in low and as he came over us he tilted his wing and smiled and waved to us. We waved frantically, and he was gone.

For a moment everyone just stood still, realizing that for that short span of time we had all become a part of something in life that was unreachable, untouchable, but would remain part of our lives forever because it was something good.

It was years later when I read the Lindberg book that I understood that feeling. In his book he talked about toward the end of the flight total exhaustion overtook him. He was alone trying to figure out the navigation problem, strength leaving him possibly from being awake so many hours the night before the flight the excitement of the trip making it a near sleepless night, and now it was taking its toll. He knew if he gave in it would be death.

Then he said a strange thing happened. Vapor like forms came into the plane with clear authentic voices figured out his navigation problems among themselves, and he was able to continue on until he arrived in France. By then they were gone too.

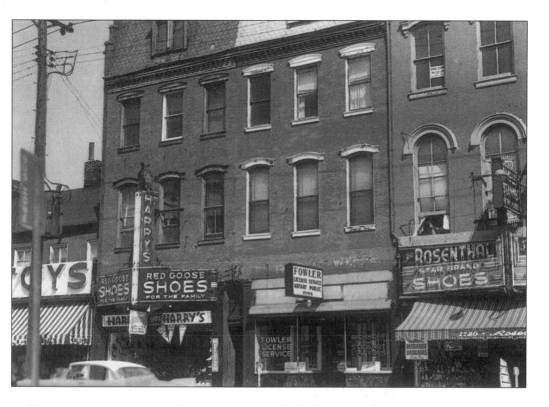

The Soulard commercial area, c. 1960.

PRESIDENT OF THE
UNITED STATES

President of the United States. So many work and dream of that exalted office, and are heart broken when they are turned down, and yet sometimes I think they are lucky they didn't get it.

History has proven that the American people can hate or fiercely love, the president.

My early memories during the Herbert Hoover Depression days were the hate that filled the conversations of the neighborhood people who would angrily spit on the ground when his name was mentioned.

The hard times—no jobs, no food, welfare never heard of—the people starved and the government of the richest country on the planet did nothing for years. Not having enough to eat of anything to be comfortable; never wishing for a choice food for the simple reason, you knew you wouldn't get it, so you didn't bother to wish.

But something started to grow inside of us that we didn't realize was happening: compassion for others, especially for our own family.

If a teenager was fortunate enough to find a job even at 14 or 15 years old (school forgotten), their small salary was immediately absorbed into the family, all of it every week, and I don't remember any of them ever complaining. They understood it was better food and living conditions for themselves, and for other members of the family too.

The big change came war, which we didn't understand but were eager to grab the new prosperous opportunities open to us. Jobs—war jobs—with undreamed of high salaries, prosperity for all, and a new President Franklin Delano Roosevelt who talked directly to us coming across sincerely, honestly, in a way we had never heard before. The whole country responded with love. They would follow him anywhere and, they did.

Everyone that could work was working night shifts day shifts six or seven days a week making money enjoying a higher standard of living and helping other members of the family.

The long war years were finally over the joy of returning servicemen a bright future. Roosevelt solidified the love of the country for him by instituting unheard of welfare programs for people. The returning servicemen could go to school for free, learn trades, get college degrees. The standard of living rose even higher, and other programs quickly followed a new era a new world. Everyone gave Roosevelt the credit. The teenagers of Depression days who had suffered through it had been given the greatest gift of all by God: love and compassion for other people.

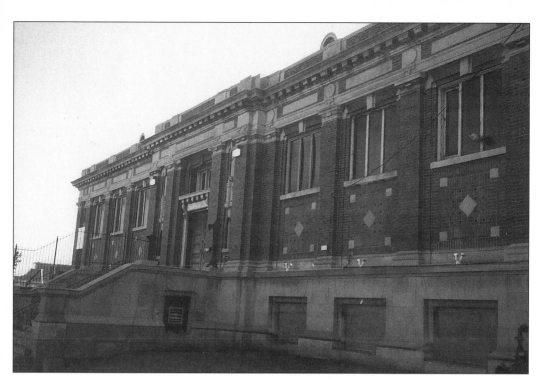

Although it is currently vacant, in its heyday, the Soulard branch of the St. Louis Public Library was the hub and centerpiece of the neighborhood.

THE CONVICT

I grew up in Soulard and spent most of my adult life there. The memories of my childhood during the Depression are still vivid in my mind. The economic hardships we endured were part of everyone's life, endured in a stoic fashion without complaining, not realizing life was any different anywhere else.

Since there was no radio or television, our outlet was the public library where I developed a love of reading that has been an invaluable asset in my life.

Families were close, welded together around the kitchen table on cold, winter evenings where family economic problems were discussed. All members, regardless of age, participated in trying to solve problems that sometimes seemed impossible to solve. Friendships were close, bound together by creating our own lives, by using our imaginations or day dreams in daily happenings which shaped our characters by constantly teaching us something like self control, love of other people, discipline to endure the hardships of the long, six-block walk to school and back, home for lunch, back and forth, regardless of weather, and with inadequate clothing, discipline to do what was expected of us.

One of these happenings concerned my friend Mary, and me. Mary lived in a flat in the next building to me, both buildings owned by Bemis Brothers Bag Company, where both of our mothers were employed, working long hours, six days a week, which gave Mary and me a lot of time alone to cope with whatever happened in the best way we could. It was the week between Christmas and New Years, a good week, for it was the winter school vacation, a time to play, a time

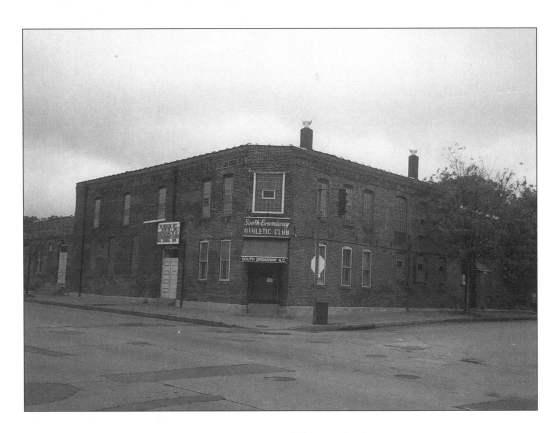

South Broadway Athletic Club at Broadway and Shenandoah.

to dream, a time to visit.

Mary's voice was clear in the cold winter air, as she stood outside on the sidewalk calling me. It was a welcome sound, for I had been idly sitting next to the stove. I grabbed my coat, pulling my tassel cap down over my ears, as I walked out the door. She waited until I reached her side, then bent down confidently. "My cousin is visiting us. He came in last night." I didn't answer her, wondering about the "he" part, quickly envisioning someone our age, possibly a duplicate of Mary—short, stocky, with wild hair.

We walked down the gangway between our houses, so I assumed we were on our way to her house to meet him. I was right. She drew closer to me, whispered close to my ear the startling news that filtered clearly through the thick tassel cap over my ears, "He has been in prison a long time and just got out."

My step slowed as the news sank in, a real convict! The face of Edward G. Robinson, the star of many prison movies, floated through my mind. An excitement built up in me, a real convict. I had never, in my wildest imagination, expected to meet one, and right here in Soulard. We walked up the long flight of outside steps to the porch. Mary opened the door which led us into the kitchen of the three room, cold-water flat.

She motioned me to follow her. We went through the next room with its double beds and into the front bedroom with two large windows facing the street below.

He stood before one of the windows looking down at the street below, so absorbed in his own thoughts he didn't hear us come in. She spoke to him. He turned, faced us with a detached, disinterested air, and said, "Hello." Mary's knowledge of etiquette didn't include formal introductions, nor did mine, so no acknowledgment of me was made to him, to my advantage, because I could look at him and form my own evaluation without hindrance.

I looked around the room for the machine gun, which I was sure he had. I saw nothing. He didn't look like Edward G. Robinson, not

The St. Louis Gateway Arch is a few miles north of Soulard, in Downtown St. Louis.

at all. He was slightly built, almost thin, but had an almost elegant air about him. He was plainly dressed, blue denim work shirt and pants, which were clean and well pressed. He had dark hair and a smooth olive complexion, bordering on the handsome side. I stared at him, enthralled. As far as I was concerned, he could just as well come right out of the movies. I had never seen anyone so confident and self-contained. I had never seen anyone like him in our neighborhood.

He turned again to look out the window, locking us out of his time, his thoughts. Mary saw us isolated. She walked out of the room and I followed. We went outside, down the stairs to the yard before she spoke again. She leaned over, confidently, and said, "He was the cutter in there. He cut out pants." How As far as I was concerned, it could have been

diamonds. To me, he was an important person.

For the next week, he occupied much of our thoughts, much of our time, by just going in and looking at him, a procedure he barely acknowledged, making him more illusive and distant, and pushing my imagination into high gear, putting him on a high elevation in my mind. As to his accomplishments in life, I let my mind wander to how valuable his talents must have been to the prison, in the pants-cutting department, completely blocking out any negative thoughts as to why he was in there in the first place. I avoided asking Mary for details which, probably being of one mind with me, she didn't volunteer. So we daydreamed on through the winter vacation, running up and down the long stairs at intervals during the day, just to be in the aura of this handsome, quiet, mysterious person, who we thought might really be some kind of undercover agent for the FBI serving time in prison just for mankind, trying to catch real criminals.

So the days passed, and it was time for school again. It was Friday, library day for me after school. I was an avid reader. The books I borrowed had to be returned that day or pay a heavy fine. It would never have occurred to me to incur any kind of debt because I had no money, so Friday was library day.

I trudged alone along the long walk to the library, selected new books and started walking back home. It was near 5 p.m., getting dusky-dark, as I walked along Broadway toward home. How nice, just to walk along, slowly, thinking my own thoughts, interfered by no one, and my thoughts were of the convict. He was everything I would want in later years for my husband. He was the ideal of everything that was needed for a full life with a good husband. I walked along, enjoying all this good luck I had by just meeting such a person, not even caring that he had never even spoken to me.

I turned off Broadway onto Victor Street, the last lap toward home. In the distance, I saw a large group of people on the sidewalk in front of Mary's home. As I came nearer, I could distinguish Mary and her mother in the center of the group with two policemen. Mary's mother was evidently in great distress, crying and using her hands to emphasize her conversation with the policemen. The group around them were spectators, seeking excitement without being involved. Mary saw me walking toward them. She broke out of the crowd and ran to me crying, "He left and took all our valuables, my mother's watch and all our money." I was stunned. Groping for self-control, trying to face reality in this impossible situation, I looked at her and said, "Who?"

Nineteenth century surveyor near the Soulard banks of the Mississippi River.

PAUL ROBESON

The year, possibly 1933, my mother made a decision that would change all our lives dramatically. She decided to enter the new era of the changing world. She bought a radio on the installment plan.

The delivery man would show us how to operate it. We stood around him intent on grasping every detail of this most marvelous thing. He turned the volume knob too much. A huge loud sound came out almost knocking us backward. He quickly turned it down to a sound I had never heard before, Paul Robeson singing the beautiful spiritual "Old Man River." I was enthralled. He was singing about my beloved river almost like he was part of it with his deep powerful voice. I knew instantly his voice was a gift from God for all to enjoy to connect us to God's Creation, The River.

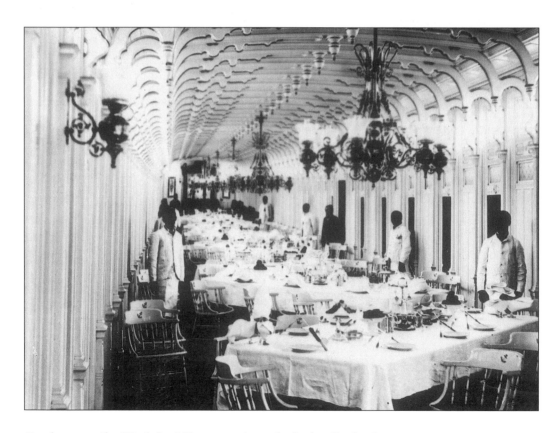

Opulence on the Mississippi River on a boat docked at Soulard.

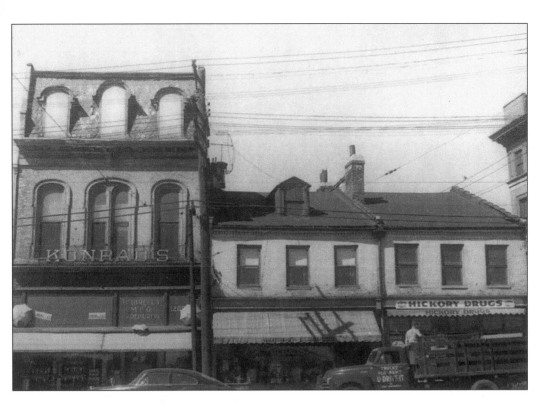

This is a picture near Broadway and Hickory Streets about a mile from the Library.

TONY SESTRIC

Tony Sestric, the neighborhood politician, our closest connection to the government. Tony Sestric, who was on our side, we knew, as if we had a side to be on, the year long forgotten, possibly late 1930s.

The river front of St. Louis, studded with countless factories making a variety of things, providing employment for neighborhood people, who could walk to work in a way combining work and home together, we didn't even know anyone who had a car.

I worked along with my friends at Bemis Brotifer's Bag Company on Second Street, a block away from my home in buildings, incidentally owned by Bemis. At that particular time, we worked the day shift. We worked six days, our salary was $12 a week.

One day we were given information at Bemis that was a real ultimatum, not to disregard in any way, to file an income tax return of the small amount of our weekly salary.

Up to that time we had never felt we were connected to the government in any way except born Americans, actually free-spirits, living a good life simply, with a radio, an occasional movie, walking everywhere we needed to go, especially on Broadway, to enjoy the brightly lit store windows and mingle with the crowds who regarded a walk on Broadway, ending at the dime store, part of their social life.

We pondered our fate with the income tax return, ending up with the decision to go to the only corner block of the government we knew about, Tony Sestric. One day after work, three of us walked up to Broadway and entered the office of Tony Sestric. He sat at a long table with two other men. He said, "What can I do for you?" We placed our income tax papers of one page, on the table before him. He said, "Oh, yes."

The paper work finished, we offered pay, which he refused. We thanked him, then hesitated. We said we had a formal complaint to make to the government. We did not like this idea of paying part of our weekly salary back to the government.

Our attitude startled him. He sat momentarily, just looking at us. Then raising both hands into the air, he burst out laughing and said, "Girls, I suspect this is only the beginning."

We walked out the door into our new world that Tony Sestric had helped us enter.

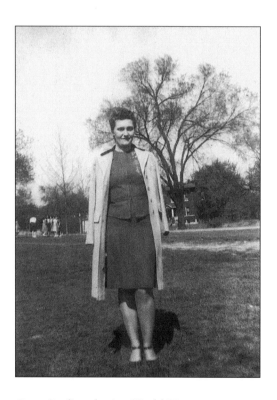

Betty Pavlige during World War II.

Soulard Commercial Site c. *1940.*

GROOMING

I suppose good hair grooming has been, and always will be, an important concern to a woman, regardless of economic status, my mother being no different.

One cool, early spring Saturday evening, my mother, sister, and I took a walk on Broadway, going as far down as Woolworth's dime store, going through the store, looking and enjoying the store activity, my mother exchanging small talk with friends and co-workers she met, passing the time, this being an important part of our lives.

We walked slowly back toward home, my mother in the center, my sister and I on either side. She stopped at various windows and looked longingly at things she knew she couldn't buy, beautifully folded, colorful towels, sheets, wash cloths, making a brilliant display under the bright lights. Sometimes a few boxes were lined up on the sidewalk under the windows filled with various articles displaying signs marked in

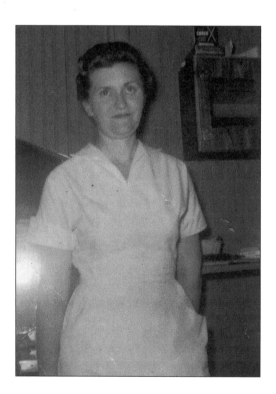

Betty Pavlige "the Beautician" for 49 years.

dark ink, "Seconds," which my mother carefully looked through but seldom bought.

We walked on, coming to a shop with an open door, an aura of an offensive odor drifting toward us: chemicals, ammonia, acid, aniline dyes, the distinctive odor of the beauty shop. We stood looking in the door at the tremendous activity going on inside. This was a large shop, occupying one long, wide room, hairdressers at their stations along both walls all the way to the back wall. This was one place that, in all my walks about the neighborhood, had previously escaped my curiosity.

The hairdresser closest to the door was setting a lady's hair in waves. I watched her hands combing first one way then the other, forming the waves, controlling the hair, forcing it under her will to do exactly what she wanted it to do. I watched, enthralled. I sensed her capability, control. Her waves completed, she picked up a small cylindrical roller from her dresser and taking small sections of hair, wrapped it around the roller. Then, slowly sliding the roller out, she had a tubular curl, the exact shape of the roller. Into this she inserted a bobby pin, She continued making her small, wiener looking curls around the head under the waves. Finally, the customer stood, without the drying period for the hair, and paid her bill, the total sum of 35¢ for a shampoo and set.

The hairdresser motioned for her next customer, from a waiting group seated nearby, to go to the shampoo bowl. My mother said, "Let's go," and I said, "No, wait!" I wanted to see more. The shampoo finished, the hairdresser brought her customer back to her station. She picked up a bottle of a thick, slimy-looking fluid, poured a generous amount on the hair, long hair this time, a more difficult job, but seemingly no problem to this person. With sureness and ease she formed the waves almost to the nape of the neck. I waited for the rollers to be picked up to make the wiener curls, but she would use a different procedure for this hair. She picked up large

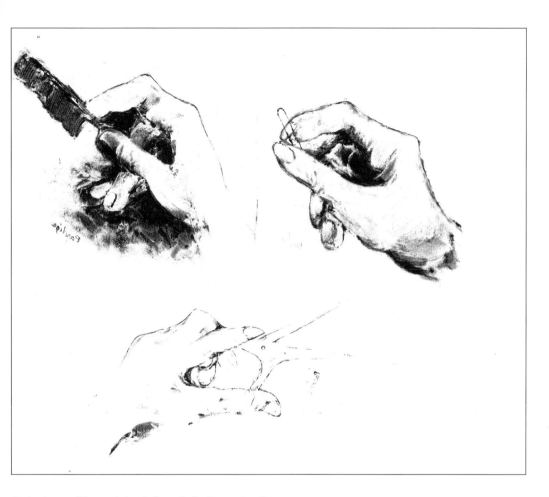

Paintings of beautician's hands by Betty Pavlige.

sections, and with her fingers formed one long, thick roll around the bottom of the waves, pinning securely with bobby pins. The coiffure finished, the patron rose to pay her bill as we walked away, toward home.

We walked along, silently. Then my mother said to me, "Tomorrow, you fix my hair like that." I was overwhelmed with that prospect and said, "I can't, I don't know how." She said to me, "Yes, you can, and you will."

Thus began the prelude to my life as a hairdresser, which would begin some years later. My mother bought the two important items that I would use, a card of bobby pins and a 5¢ bag of flax seed, from the drugstore which, when boiled with water, reached a

very slimy, thick state, hopefully, like they used in the beauty shops.

I soon learned that I couldn't make waves, no matter how much slime I put on, and I also had a demanding, free customer, who had invested in bobby pins and flax seed and was determined to get her hair done exactly the way it was done on Broadway.

I combed, I pushed the hair, first one way, then another. It didn't form into waves, each attempt bringing inspection and rejection. I went through a dilemma common to artists and writers confronted with a commitment, the blank page, knowing the job had to be done and having to pull it out from inside yourself. But how to do it can amount to

almost a horror.

Thus began my infringement on the knowledge of others, in this case, very necessary, for the professional job my mother wanted, and which I was incapable of doing at the age of 10.

After that day, a walk on Broadway was never without a purpose, to stand at the open beauty shop door and hope to visually accumulate the information I needed, how to make waves. But I learned then, as I did in later years, that it isn't as easily done as it looks, the secret being repeat performance plus using your own ingenuity to solve the problem.

Then, from deep in the bowels of the factory where my mother worked, a motivator soul reached out to me, unknown, unseen, but just as effective. She said to my mother, "I like your hair."

That was what I needed, the salve for my artistic ego, to spur me on in the creation of waves which I attacked with a new determination to succeed.

I insisted my mother wash her hair every day, so I could try again and again to please my unseen motivator, the one person who liked my work. Each day I waited anxiously for my mother to come home from work, my first words being, "What did she say today about your hair?"

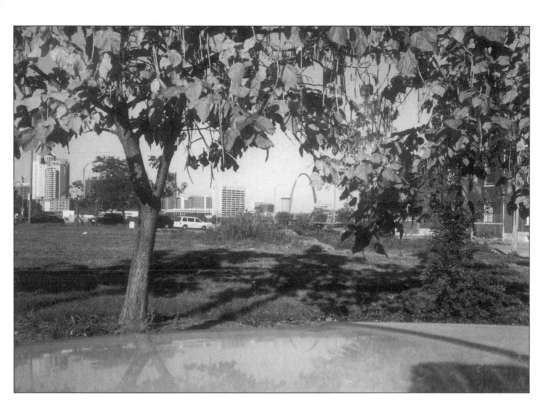

View of Downtown St. Louis from Soulard North End.

SOULARD

I suppose every big city has a Soulard area. One of the first settlements of a growing city with working class people, a mixture of nationalities, not far from downtown, not far from the Mississippi River, not far from the industries that provide a livelihood for most, not far from anything that was important to many who lived in the area.

My life since childhood has been lived in St. Louis's Soulard area, even after joining the exodus of many long-time residents in the 1950s. On a corner of that neighborhood, at Ninth and Shenandoah Streets, was the one-room world, my beauty shop, that has housed 49 years of my workday life. A room that provided hair care for countless women, many of whom have long ago moved to the suburbs but still came back regularly, many of whom became lasting friends.

I opened the shop with one thing in mind: security. I hadn't counted on the love that would develop for the shop, the pure joy of having a job that was a created effort. It involved the physical, mental, and since I was concerned with the welfare of the customer, the spiritual. Before it was all over I learned how to pray hard, for myself and for others.

It was also a form of self-education. The long hours between appointments provided the time for reading scores of books, some good, some bad. If I liked a particular writer, I'd place a high value on what he had to say, referring back to some passages to refresh my memory so that I wouldn't lose the enjoyment of that thought. I felt that by reading I had access to the thoughts of learned people whom I could never meet or talk with, but that wasn't necessary anyway, for by reading I felt myself a visitor. Only I was the listener, which I didn't mind at all.

Montaigne had a firm rule that his guests must not be boring or they were excluded from his presence forever. Well, maybe he was in a position to endorse that rule. In a way, so was I. 1 could close the book.

The quiet reading was good because it provided a restful stillness of body that I sorely needed. The work in the shop was physically hard, and I had my duties at home being a wife and a mother to my small daughter.

Every hour at home was a race with time trying to get everything in order so that when I returned to the shop it wasn't at the sacrifice of my home and family.

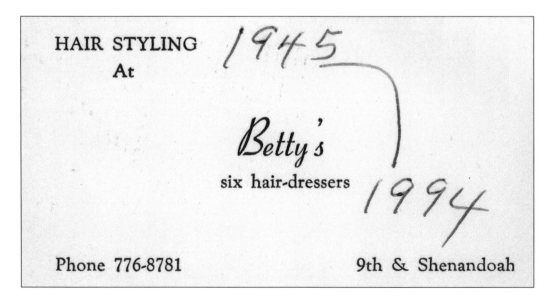

Business card for Betty Pavlige and her five employees for 49 years.

Painting by Betty Pavlige.

HALLOWEEN

It was Halloween—cold, blustery, and a busy day at the shop. It was also Thursday, our night to work late.

A late night to work on Halloween could be a cause for concern. The day started wrong. Someone with a morbid sense of humor deposited two black sick kittens on our doorstep. We were busy, unaware of it, until the door opened. I called the Humane Society.

There was no place to confine the kittens except the rest room, which proved unsatisfactory since they were sick, so I just let them pick their own place to sit, hoping it would be a small area somewhere. It was near the feet of one hairdresser. She was unhappy about it, mostly because the others thought it was funny, since she had to stop quite often to use paper towels to clean up after them.

My concern grew, not so much for the discomfort of all, I must confess, but because it was possible the inspector could come in unexpectedly, and animals in the shop, even on humanitarian terms, was not allowed.

In the midst of this, Tommy came in. I sent him on an errand to purchase candy for the evening trick-or-treaters. He returned unhappily. He couldn't understand that we were giving all that candy away, and not to him. As he left for home, he jokingly assured me he would return that evening as a trick-or-treater. Just what I needed.

The Humane Society was slow in coming for the kittens. The situation was becoming more intense. The hairdresser with the kittens under her feet wasn't taking the situation lightly. She snapped at one rather hefty hairdresser, "I know how you can lose weight real fast—cut off your fat head." I knew it was time to take action of some sort. Just then a head came in the door, the Humane Society officer. We were saved.

Anything you do can be an art by looking for the good in it and doing it to the best of your ability, with intensity. It doesn't even have to be the so-called creative arts. It can be anything. Any job you have, truck driver, teacher, cook, just make up your mind to do it to the best of your ability. In doing so, you are making an art of it. You are reaching above the average level and that's what makes life exciting. How dull life can be always going down the same old road, not looking to the right or to the left. To look beyond, to reach out, to include others, but always to good purpose, that's the secret for a full life.

The shop activity went on five days a week and two evenings until 7 p.m., regular, steady. The girls were busy. The, short, curly permanents were to stay a long time. I kept the prices low because of our location in an old neighborhood. We depended on volume and quality. We surely had both. The girls were good, there was no doubt about that. Customers came from a 50-mile radius. In bad weather I was sometimes amazed to see a little old lady drive up at 8 a.m. sharp for her appointment, coming in from a long distance. I would think neither rain nor sleet nor snow can stop the mail, or little old ladies with 8 a.m. appointments at their beauty parlors.

Which reminds me of a mailman who served the shop for a long time. I thought he was a deaf mute. He would come in, and if I was near, he would hand the mail to me and acknowledge me with a grunt. I would, for some reason, do the same. If I was across the room or answering the phone he would pantomime the act of laying the mail on the table with a flourish and a salute, while I soberly pantomimed every gesture. No one seemed to think our actions were strange.

Then one morning a new customer came in. As she was ready to leave, the deaf-mute mailman came in. We went through our usual pantomime routine. As he turned, she said,

"Well, hello there, Mr.___.""

"Well, hello Mrs.___. How are you?"

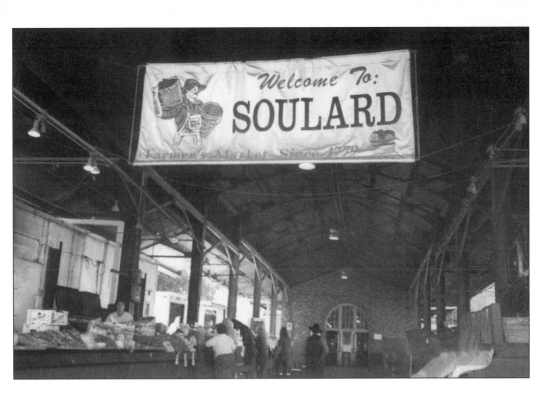

Soulard Market.

BEAUTY SHOP MEDICINE

The two elderly women sat next to each other under the dryers in slightly turned positions, heads partly out of the dryers, causing the dryers to make a louder, rougher noise, which didn't bother them in the least as they carried on their weekly social visit, discussing their ailments, their medicine, the color of their pills—which they would probably swap before the visit ended with, "Why don't you take a couple of my orange ones, they helped me," and the other—wanting to return something—insisting she try a couple of her pink ones.

I usually listened as I worked, not agreeing, trying to calm myself with, "I haven't heard of anyone dying from the exchange yet."

At that time we had many elderly customers in Soulard. The war was over. The exodus of the young had begun: an exodus toward the country, the suburbs, seeking a change—a new life—from the terrible war

Steeple of St. John Nepomukebo, Eleventh and Lafayette.

years they had endured and, leaving behind many elderly who were reluctant to leave Soulard and their past memories so they stayed—usually living alone in three rooms—adjusting to their lot in life, which was peaceful compared to their own past in the war years.

They usually followed the same pattern: Soulard Market on Saturday morning, church on Sunday. They had many choices. Soulard was the first established neighborhood of a new St. Louis, and churches of various denominations were built at that time of such strong rock structures that they would last for generations actually centuries. On warm summer evenings people sat on the front steps of their apartments talking, laughing, watching the world go by. In the winter, some—if they could afford it—watched the newly invented TV, alone in their apartments, quickly becoming a part of the new generation of TV news, soap operas, whatever.

Luckily for us their weekly trip to the beauty shop was on a weekday, leaving late Friday and Saturday for the ones who worked, which was a real crush. The younger hairdressers liked elderly customers, sometimes feeling protective of them in some ways such as watching their complexions, knowing the color of the skin, which had many indications of the health of that person—good or bad.

One of my memories is of hearing the comment, "Mary you look kind of pale—maybe you ought to go back to your doctor and get some of that blood medicine." I raised my head from my work, looked across the room to Mary—a tall stately woman—a quick comparison crossed my mind—a creamy ivory, waxen Easter lily. I said nothing—reminding myself I had one job—seeing that the work was done right and keeping the shop on a decent schedule if that was at all possible.

I would have no part of the beauty shop medicine, but would secretly think to myself, "red beets or red wine builds blood," I had read somewhere.

The Bemis Brothers Bag Company, vacated today.

CRISIS AT THE
BEAUTY SHOP

It was a hot summer Friday; a busy day at the shop. A storm was approaching. The sky darkened enough to scare the timid ones into the shop for company and solace, whether or not they needed a shampoo and set. Their fear of storms always mystified me, an alarm so severe that their faces paled and their voices quavered.

But their fear never quite matched Tommy's. He was usually our first storm visitor, sitting in his usual erect position talking about his lack of fear of storms. I had my usual comment, which I thought covered it all, "This building has been here nearly a hundred years and hasn't been blown away yet, and I don't think this is the day it will happen." No matter how emphatic, it didn't change anybody's mind.

On this day, with storm visitors adding to the workload, the rain was a deluge straight down and heavy.

One of our more affluent customers was present, a lady who lived next door to a famous, handsome Cardinal baseball player. The hairdressers, trying to find out personal things about him usually plied her with questions. But she was a good neighbor. She gave out no information, which made it more intriguing for the hairdressers. Each time she came in they tried a little harder, a game they all enjoyed.

A very elderly white-haired lady, her work finished, stood by the door, waiting for the rain to let up so she could go home. She

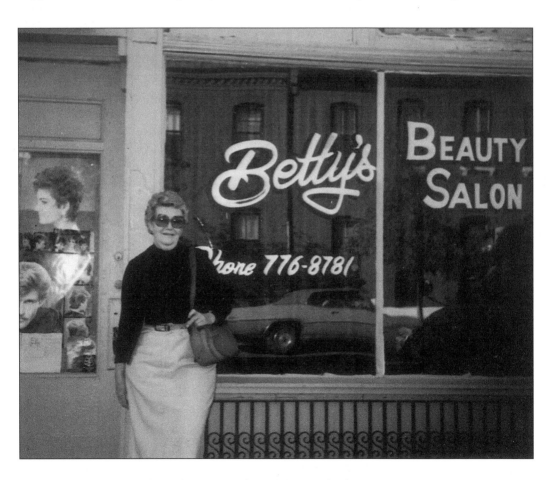

Betty Pavlige in front of her shop at Ninth and Shenandoah.

waited and waited. The rain continued. The streets were full of water and the gutter overflowed.

The baseball player's neighbor was also finished. Her husband came to get her, a large black funereal-looking umbrella over his head, his face as gloomy as his umbrella. He couldn't understand the long trip each week to this kind of a beauty shop.

They talked to the elderly lady waiting at the door, and graciously offered to drive her home. All three moved out to the sidewalk squeezing close together under the big umbrella.

The man hastened to open the car door and assist the ladies inside, stepping over the small river that was even with the curb.

The elderly lady stretched her legs to make the big step and her handbag slipped off her arm into the curb river and was gone toward the sewer at the corner.

Hysteria reigned. The three came back into the shop, all wet, all talking at once. Her money, the sum of $5, and her door key, all in the handbag. What to do? They gave the problem to me.

I had a vague vision in my mind of the handbag floating to the sewer and staying on top of the water (an utterly mad idea). All you had to do was lift the sewer lid and pick up the handbag. The rain continued heavy, straight down. I'd get help for her. She was a citizen. I called the police.

They arrived, two young, handsome police officers, in their early 20s, dry and very important looking. They had misunderstood the call. Their first question to the three people was, "What did he look like?" They hastened to explain, all talking at once.

This was a routine job to the police. They would straighten it out, and besides, they had a nice audience. They hadn't overlooked the three young hairdressers in their age bracket, especially the dark-haired girl who was exceptionally attractive. Their eyes wandered and stayed on her.

They stood straight and tall. They raised their hands importantly. "Wait a minute. Let's get this straight. What did he look like?" Bedlam reigned again.

My thoughts were on the handbag floating on the water in the sewer, or so I imagined. I had to intervene because we had to get back to work. I explained that there was no robber and offered a solution. We would simply raise the lid on the sewer and pick the handbag out. They were dumfounded. To go out in all that rain and lift the sewer lid! They were here to solve a crime in a prestigious way, their hairdresser audience hanging on their every word, their every move. They were the police, important. That wasn't their job they assured me!

As they stood before me I saw them differently—young kids in clean, pressed uniforms, protesting that this wasn't their job. It was raining hard, they'd get wet and the most valid excuse of all, they had no tools. One had short, curly hair. He shook his head vigorously in protest. I couldn't accept their excuses. This was far too important. I held out a large screwdriver. I'd ask nobody to do a job I wouldn't help with. I'd go with them.

They stood before me helplessly. They knew they had lost. We went out the door in the rain toward the sewer. They struggled, the lid was stuck but they were strong and evidently had lifted sewer lids before, in dry weather. The lid came up to reveal swirling, muddy water but no handbag.

Back in the shop we went, very wet. The elderly lady was inconsolable. Her money and her door key were in the bag. How would she get into her home? They stood before her. The rain dripped from the one officer's curly hair and ran in rivulets down his cheeks on to his chest, over his shoulders. The boys looked nothing like the slick images of the police on TV shows, and their chances of impressing the dark-haired beauty were washed out. Fate had been unkind.

Meanwhile, the elderly woman continued to weep, a picture of lonely helplessness.

Compassion rose slowly in the eyes under

the wet curls. The policeman stood silently looking at her then held out his hands towards her. "We'll take you home and open your door."

Out in the rain walked the three toward the police car, the elderly lady between the handsome officers, and my screwdriver gone forever.

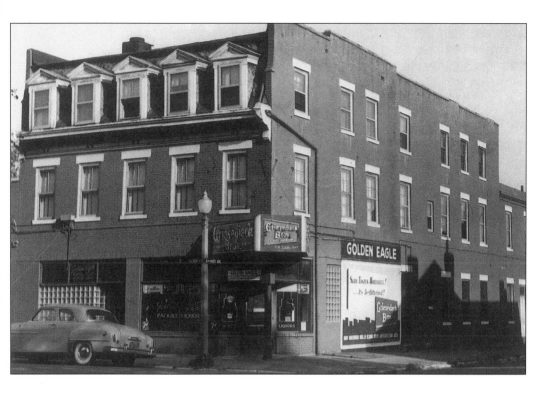

Soulard Commercial Site c. *1940.*

DUKE OF SOULARD

What do you do when you are a dog in Soulard and one day you return home from one of your Soulard jaunts and find your owner has moved away? At first you don't believe it, so you wait. The house is silent and no one is around, and then you start to believe it, you are abandoned. Who would have ever thought it was necessary to sit home and watch them?

Well, first things first. You get up off your haunches, stretch your huge frame to relax, then think yourself out of this situation. What first? Of course, the food problem. The first one to come to mind is a young man, a waiter, who lives in the corner apartment, a likely prospect who might bring leftovers home. But a flaw: he has a dog that he has ruffed up a couple of times, but oh well, worth a try.

He jumped at the door which was a great effort. Must be an easier way. He scratched on the door, hard. There was no response.

Eighth Street Home.

He knew from observation that the young man was gone at night and home during the day. He scratched again, and then on second thought bumped the door hard with his shoulder. A noise inside, a sleepy, "Just a minute." The door opened. The young waiter stood there trying to figure out what the situation was. Duke used all of his Alpha state of consciousness to transmit—food. The relaxed, sleepy waiter got it. He said, "Okay, wait," closed the door and was gone. Duke waited. The waiter returned with a bowl of food, mostly steak bones, which had cost him nothing. So, he was right, he did bring home leftovers.

He was smart enough not to push a good thing too far. He tried to think of others. Of course, Paul, an older man whose dog had died, but now Paul lived in subsidized housing and observed the strict rule of no pets, but that didn't mean you couldn't feed them, so he promptly bought a large box of dog biscuits and waited for Duke's next visit, and he was surviving. He had discovered it wasn't necessary to be hungry. He could always round up food by knocking on someone's door.

There was another problem he couldn't solve: no home, no warm place to stop on cold winter nights, and winter was just setting in for it was November. Sitting in dark corners, looking up and down a deserted street was deflating, to say the least.

One early morning he saw a tall, well-dressed man come out of a hallway holding the leash of a large, female dog. Together they started on their morning walk. Well, might as well check it out. The man gave him a startled look and said, "Get away, get away," but not before he discovered the female was spayed. As he walked with the man and the dog, he felt once again part of a family, even though he hadn't been accepted yet, at least by the man.

The walk over, the man took his dog, he had learned her name, Muffin, and went in his hallway, locked the gate and left him outside. He knew one thing, their routine, and the next morning when the gate opened, he was

waiting to take a walk with them.

It was love at first sight for Muffin. She softly grabbed his nose in her mouth, a gesture of ownership that the man recognized, and he agreed that Duke could live with them. Duke had hit paydirt, his new-owner, Bill, a retiree from Busch Brewery, had a big pension, and a generous heart. The food bowl was always full, there was no need to knock on doors anymore, and he shared a rug by a warm heater at night with Muffin. He was set.

The winter passed, spring came, and a restlessness stirred within him. The morning walk had lost some of its appeal for him. One morning he ran ahead, turned and looked at them, then turned away and was gone. The days passed, then one morning as Bill and Muffin came out of the hallway, they were met by a thin, gaunt, Duke, who weakly and submissively greeted them. Muffin jumped with happiness to greet him back into the fold, completely forgiven.

It took days to resume his strength. He slept soundly, day and night. Feeling better he went out of the gate, down the hallway to the sidewalk and sat down and looked up the street. A noise across the street caught his attention. He watched an older woman unlock the trunk of her car, put something in, then walk back into a door of a small shop. He watched. Funny, he had never paid any attention to that place. He walked across the street, put his nose up against the glass door and looked inside to another world, a beauty shop. There were women inside, doing just what, he wasn't sure of.

Someone came up behind him and opened the door. He went in too and stood there. The older woman looked at him but said nothing, but a younger black-haired one on the other side of the room said, "Where did that dog come from?" She flung the door open and said loudly, "Out, out." He went outside but he didn't leave. He decided he liked the place.

Thus began his life at the beauty shop. He wasn't easily accepted by the younger one, she talked negatively about the inspector, and offending customers with a dog there. He tried to vocally defend himself to which she answered, "I don't know what woo-woo means," but she was starting to relent and little by little he wedged his way in, and what a joy it was! He discovered that most of the people that came there liked him, and he came to recognize their cars and went to greet them and escort them down the sidewalk and into the stop. Sometimes they brought special treats which were dropped into a large food bowl that one girl brought, plus a bag of food, so the bowl held more food than he could possibly eat, so he started to share with other dogs. When the weather was warm and the door was open and the shop was busy and no one paid attention to him, it wasn't unusual for him to bring a scrawny, dirty, dog to the bowl and stand guard until the food was hastily eaten by the visitor and then they both retreated outside to avoid trouble. The black-haired girl saw what was happening, free hand-outs, but decided maybe it was necessary to let it pass, until one day he brought a cat in, strangely, black and white, the same color he was. After the cat ate and ran out, she went over to Duke. She bent over, took his face into both hands and said, "Enough is enough. Don't you ever bring any more cats in here, do you hear me? No more cats."

He avoided her eyes and looked beyond to the other side of the room, his way of saying, he wouldn't promise.

Muffin watched all from across the street, sticking her face through the slats of the fence where she had a good view and even if the gate was half-open she never ventured out, for she was strictly disciplined. She really wasn't left out all the time. If choice bones were put in the bowl, he would pick up two in his mouth, go across the street, into the yard, drop them, let Muffin take her choice, and he would take the other one, lay down, and chew on it.

The shop was only open three days a week, but he came when it opened and left only when it closed and he was ushered out on the sidewalk, when he reluctantly walked across the street again to Bill and Muffin. He found

the other days were a sort of letdown and he started to wander.

One late afternoon he discovered a group of friends who gathered outside a tavern in Soulard waiting for their owners inside who had stopped at the tavern after work for a drink with their friends. Since dogs were not allowed inside, they waited outside the door until their owners came out. Duke congregated there also. His horizon was widening.

One afternoon as he sat among the group, he saw a girl and her dog come out of a building down the street and walked toward them. He watched them. The girl was relaxed, happy. He liked her immediately. As she came to the group she bent over, talking to all, as if they were old friends. He wasted no time. He pushed forward, greeted her enthusiastically at which her dog, Marie, showed her resentment. He sensed, another spayed, but no romantic like Muffin. This one meant business. He held his ground against her and edged his way into the heart of one of the

Bob Brandhurst

most important people of his life, Joyce Sonn, who would put her compassion, and money, to the test of one day soon getting him out of the dog pound.

Thus began his life with the more influential of Soulard, Joyce Sonn, who would introduce him to the influential developer of Soulard, Bob Brandhorst, who one day would relax his iron-clad rule of no pets in subsidizing, just to allow anyone who-would take Duke inside at night in winter to do so.

It was a few days before Thanksgiving. The weather was rainy, dark, and murky. Duke had been gone on one of his neighborhood jaunts for days. As if to make things worse, Bill, who had a history of a chronic heart condition, became very ill and had to be hospitalized. Muffin was left on the porch alone.

From his hospital bed, Bill called Joyce Sonn and told her of the situation. She went over to see Muffin, taking her food. Then she toured the neighborhood looking for Duke. He was nowhere around. As a last alternative she went to the dog pound. He was there. She paid his fees and brought him home to the porch and Muffin.

Everything seemed to be under control until the weather bureau forecast predicted an Arctic blast was on the way with extremely cold temperatures. Bill heard the forecast and against doctor's orders, signed himself out of the hospital so that the dogs could sleep inside at night.

After Bill returned home again, all seemed well again, for awhile, until due to his health, he had to make the difficult decision of moving to a senior citizen complex where he could be helped in his efforts to live in an apartment alone, and he couldn't take the dogs.

The people who lived in the apartment below Bill had agreed to take Muffin, but not Duke. Joyce Sonn had searched the neighborhood for a home for Duke and Bob Brandhorst had relaxed the rule of no pets, just one time, to try to help Duke, but up to now, Duke had no home, even though he was young, healthy, and had a terrific personality.

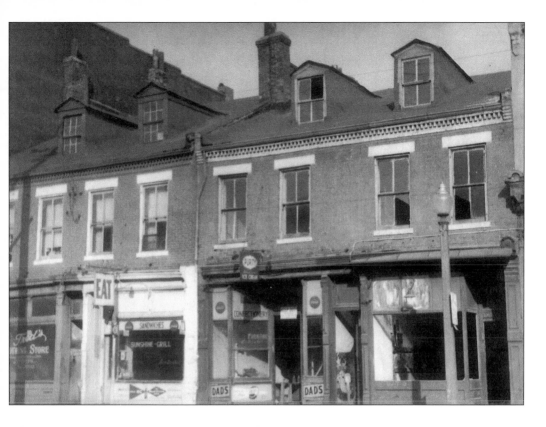

This antiquated image shows how Soulard used to look. .

SIN OF OMISSION

Every day of our lives is a learning period—if we are sharp enough to recognize it, to use it to enrich our life, to help us, or others in some way. To recognize it is the important thing. An important learning period happened to me one Friday morning in the shop. A learning period that holds me to this day in its grip of hard work, grief sometimes, but over-all a sense of place, in a closeness to God.

Friday in the beauty shop—always a busy, hectic day, trying to give service on time—the work finished properly as quickly as possible because most of the morning customers were waitresses or bar-maids from the countless taverns downtown and also Soulard, which is actually a downtown area. The weekends were the customer's busiest time and, of course, their hair had to be done in a nice fashion of the countless styles of that time.

She was about 27 or 28 and gave the impression of intelligence, coordination, which I noted instantly with the thought, "I'll bet she's good at her job," and of course always thinking of myself, my last thought, "I'll bet she would make a good hair-dresser." She handed me the money for her hair and said loudly, "Thank you for getting me out this early. I have something to do before I go to work and, I'll do it. I do not have the sin of omission. If something is put in front of me and, I know it's right, I'll do it. No, I'm not guilty of the sin of omission," and she was out the door. I stood still in a stunned silence—watched her walk across the street to her car—I know a profound message when I hear it, like it was straight from God. My peace was gone. I felt a remorse, guilt for not doing things that had been put before me, things I had ignored, hurt people. I turned back to my work, in an instant a changed person—forever.

Joyce Sonn at her desk at Y.E.H.S..

Rehabilitation work being done at mid-19th century buildings in Soulard.

HIPPIES

It has been said, and rightly so, that there is nothing new under the sun, it's all repeat performance. In the case of Soulard, I would say that is so.

The exodus in Soulard in the late 40s and 50s changed the face of Soulard, the first settlement of St. Louis. The war was over. The boys, what was left of them, were home again. It was time to start a new life away from all the bad war years and their strife and worry. Money and jobs were plentiful and everyone wanted a change to subdivisions in the suburbs, or just larger homes in the more affluent neighborhoods of St. Louis. The change came and left Soulard resembling a battered area on the decline. The beautiful old buildings with their now unheard of 13-inch walls, were left standing as old sentinels

The Youth Education Health Center of Soulard was founded by Bob Brandhurst and Associates.

on the war front. Buildings, in good condition, were sold for $2,000–3,000 dollars, anything just to break all ties with the past.

A rumor drifted into the beauty shop that there were hippies moving into Soulard, one boy with a long ponytail hanging down his back and a guitar over his shoulder. He had bought a house near the old St. Peter and Paul Church. Another handsome boy, a companion of the hippie, with curly, auburn hair, and a girl, whose high lyrical voice sang out with beautiful folk songs to accompany the guitarist, all sat in the summer evenings out in their courtyard with other friends, their voices echoing through the empty, deserted buildings around them.

Rumors in the Beauty Shop, such goings on were never heard of in Soulard, all that hair, as if their main purpose in life was to grow hair, but what they didn't know, or bother to find out was, this was an unusual group.

The ponytail covered the head of a Yale graduate, fresh out of school, dreaming dreams, making plans for his future, which included Soulard. The auburn-haired boy was also just out of school, Harvard, and he too had dreams as he watched the beautiful singer who had just graduated from the University of Arizona. They were a unique group, no doubt, to Soulard.

They had plans they discussed as the summer evenings wore on into the night. They saw a future in Soulard. This land was invaluable, it was the only land that would ever be here, this place would be forever, and the buildings were being sold, dirt cheap, but the three were just out of school, with little money. It took money to buy the buildings and the rehabilitation would be costly. What to do?

One night a new friend entered the young group, Ruby, a past middle-aged, old-time Soulard resident, and a business woman making her living and raising her family with her tavern on the corner of Menard and Russell Streets. Ruby was the old grain of Soulard: hard-working, honest, practical,

This hat factory, when empty, eventually became a one-block long senior residence.

facing problems with common sense, which had been developed out of dire necessity, because her life had been a long, hard, working life.

Ruby had been worried about the decline of Soulard and her heart was heavy as she saw building after building standing empty, decaying away as cold, winter weather took its toll with icy winds whipping through broken windows, freezing water pipes, which later burst and caused more damage.

Rumors of this group had drifted into her business too, and she took action. She walked into the courtyard, sat down among the singers, and listened. The singing went on, cups of beer were handed out, she joined in the singing and the beer. She could sing too, the beer mellowing the voices. The soft summer breeze felt good, and somehow, this seemed like old Soulard, and she was

young again, and her life was just beginning. The singing stopped and it was reality again, and business time.

They talked on and on, they needed money, they had a plan, they could ask the government for money. How would that be done? Well, use a little common sense, what's wrong with going to the government and asking. Excitement grew, voices became louder as the plans unfolded. Rent a bus, pool their money, they could cut corners by eating sandwiches on the way. They would go and ask, regardless of the chance of failure.

Ruby was caught up, she liked this attitude, she knew, deep down, this was exactly the right thing to do. She stood, raised her arms and said, "Take me, I'll go too."

The long bus ride to Washington was

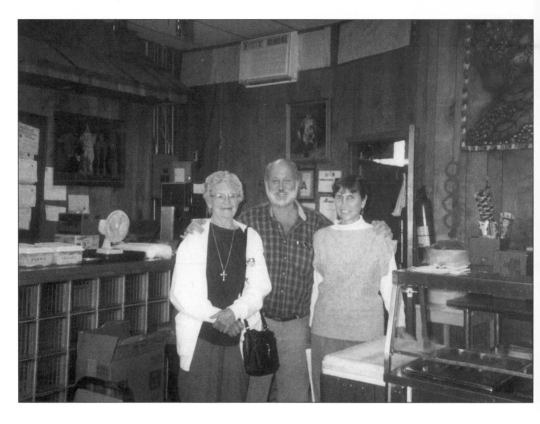

Betty Pavlige, Bob Brandhurst, and Joyce Sonn in kitchen at Y.E.H.S.

successful, the low-cost government loans were procured, but most importantly, it turned the attention of Washington toward Soulard to get federal aid to help old Soulard residents, and the young growing up, much needed programs.

Ruby didn't live to see the complete, big change in Soulard, but she saw the long range needs. When they returned from Washington, she donated two Soulard buildings to the newly formed Soulard Association that would assist the youth and the senior citizens of Soulard for years to come. Maybe, too, with her association with people in a business world, and her ability to evaluate people, she saw another facet in the young people there that night, humanitarianism, a quality of compassion that only God can give to anyone, compassion plus action. She saw that it was deposited in the young Harvard man, Bob

Brandhorst, and the young singer, Joyce Sonn, whose actions and plans, put above their own personal lives, would weld Soulard together in its long struggle of rehabilitation and new growth. Their lives would change dramatically, and their young years would be left behind as they were drawn into this struggle for existence of the senior citizens of Soulard who were caught up in a dramatically changed position as speculators. The word about Soulard was out. It started the buying of Soulard property, the rehabilitation, the charging of enormous rents that the elderly couldn't possible pay, leaving some of them who had no family, homeless and without assistance.

Joyce's training in social work enabled her to work with the young in Soulard, under the *Youth, Education, and Health in Soulard* program, but more was needed for the

elderly, more than she could give. Much of her time with Bob was spent in discussion of the elderlys' problems. Something had to be done, but what? Most of the elderly had lived in Soulard all their lives, working in industries close by, walking back and forth to work, sometimes even coming home for lunch, leading pleasant, long lives, but making small salaries, which in later years resulted in small social security checks because of a small amount paid into the system. Now, with inflation, they were left behind in the great money rush.

It was a cold winter day, the dark gray clouds hung low over a figure walking slowly over Twelfth Street near Russell Avenue. Bob Brandhorst walked slowly, stopping occasionally to look at the rehabilitation being done on a newly gutted building, or to look at an abandoned one, boarded up, waiting to be rehabbed, or forgotten until a later date, projecting a lonely picture, adding to his down feeling, for he had just left Joyce who had related from the elderly to him, of being given notices to vacate their apartments and had nowhere to go.

Actually, he couldn't relate to their situation from a personal standpoint, as he had come from an affluent family, his background being not even remotely connected to conditions in Soulard, but he couldn't disregard their problems, something had to be done, and soon, but what?

He was nearing the corner of Twelfth and Russell. He stopped, looked around, and buttoned the top button of his coat. The strong, cold wind, from the low-slung clouds indicated weather was on the way. The large,

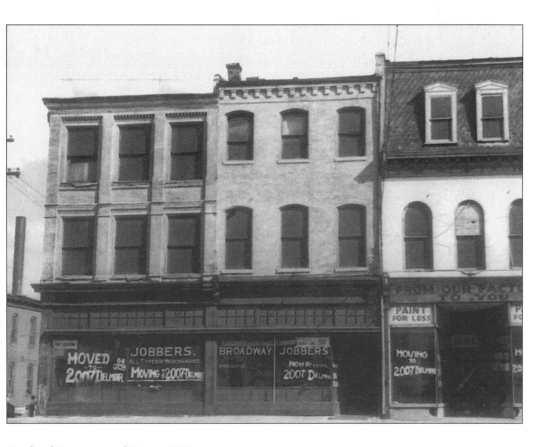

Soulard Commercial Site c. 1940.

67

empty factory building, called the old hat factory, on the corner of Twelfth and Russell, faced him, looking cold and lonely and abandoned. It had been standing there, empty, for many long years. He stood looking at the building, he saw it so often, it was just a thing you passed and repassed.

Suddenly, he was seeing the building in a different way, as a building made into apartments, living quarters for the Soulard elderly. The thought jolted him. He almost ran across the street to the building. He ran down to the corner of the structure, cupped his hands around his eyes, peered in a window.

His excitement grew, it could be done, he knew it. He turned, ran down the street toward Joyce with the news, his plan, to rehab the hat factory.

The success of the rehabbing of the hat factory into 100 government subsidized apartments for the elderly, stands out like a beacon of new Soulard, an indication of another era in an old area, that still has the spirit of old Soulard that exists in the hearts of the young of Soulard.

Betty Pavlige, Bob Brandhurst, and Joyce Sonn in kitchen at Y.E.H.S.

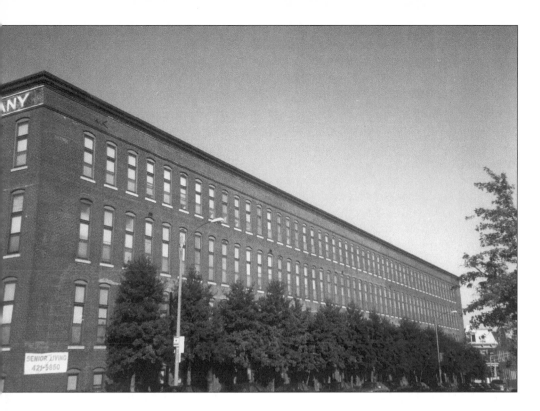

The Hat Factory which is now senior residences.

FOUR WALLS

Before social security, the elderly were kept in the family group, but after they started to receive their monthly check and their independence, they were out on their own in their own apartment alone. Usually their children felt no pressing need to be too much concerned about them, after all they had all their financial and physical needs taken care of. When the holidays came around they were included or they weren't, depending on the children's whims. At that time there were no senior citizen centers or groups. If you lived alone you tried to find companionship with your friends, unless you out-lived them, or the next door neighbors who talked to you on the porch or in the yard, if you saw them. You went to Soulard Market on Saturday morning, actually that being the highlight of the week for sociability besides doing your marketing.

She was tall, thin, neatly dressed, possibly in her late 70s, but very agile. She lived alone having only one child, a son who lived on the west coast and came to visit her about once a year, having his family and obligations out there. She came to my shop for her hair care and I enjoyed her visit, as well as her patronage.

The Christmas holiday season was coming and my shop was busy. She came in quietly, took her seat to wait her turn. She was quiet. I sensed a sadness. I tried to make conversation about the holidays asking her about her plans.

She looked at me in the mirror and said, "I haven't any plans. My son doesn't visit me this time of year," and she added, "I just sit in that house every day looking at those four walls and I go to bed at night and when I wake up in the morning they are still there and I look at them again until night."

I was young, in my 20s, and I had no awareness of such a situation. I couldn't answer her. I felt a deep hurt for her that I couldn't transmit back to her. I suppose you can only give what you are.

It took many years before a handsome, curly, auburn-haired young man solved her problem, Bob Brandhorst, and she was long since gone.

Fortunately for the remaining residents of Soulard, Bob Brandhorst was instrumental in having the government establish apartments for the elderly in an abandoned hat factory. Space was also provided for a recreation room. Now there were programs to be involved in, things to do.

Many of the elderly no longer had to be alone to worry about the four walls. They could be happy, the way God wanted them to be, even if they were 80 or 90 plus.

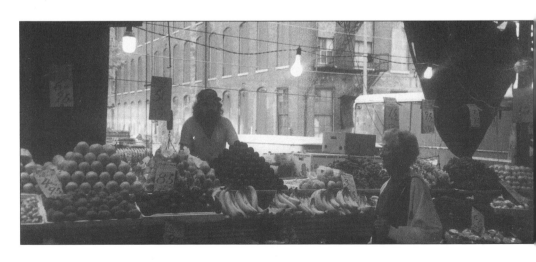

Soulard Market.

Pontiac Park, Ninth and Ann Street.

THE BIRTHDAY

Time passed slowly for her as she sat next to the bed of her 92-year-old mother who slept soundly, her breathing slightly labored, but methodical. She felt peaceful, but not without a down feeling of sadness, for this was her own birthday of 71 years, and there would be no celebration of cards, cake, or presents for her because they were the only survivors of their small family.

The winter sun was warm on her arm, coming through the window. The huge windows were one of the reasons she had chosen this nursing home for her mother. She thought it would be a pastime for her to see the outside world, as much as was available to see, for her room faced a busy city street, the constant stream of cars and movement could occupy a lot of her mother's time, and make her feel part of the outside world.

She sat quietly, her thoughts reaching back into time, other years. She had been the second born to her parents but the only survivor, the older sister dying in infancy, so she lived her life as an only child, her parents lavishing all their time and affection on her. They had been a close-knit family. Holidays and birthdays had been cause for celebration with good food, presents, fun, and laughter. Her life had been filled with love for them, and she had felt no desire to include anyone else, even a husband, so she had never married.

After her father died, she had lived alone with her mother for many years. Right before her mother's 90th birthday, she had been forced to put her in this home for her own safety, since all reasoning seemed to have left her, a condition the doctor called senility, and she would get no better, but worse. She had no choice, but she tried to soften her own guilt feeling of placing her in the home by going there often and just sitting by her bedside, even while she slept.

Any reality seemed to evade her mother, even the reality of recognizing her, thinking she was Mary, the sister who had died in infancy. At first she had felt hurt, upset by the mistake,-but after being reassured by the doctor that it was part of her senile condition and couldn't be taken personally- she accepted it and answered to her sister's name and tried to feel part of the weird conversations that her mother carried on with her.

Her mother stirred, opened her eyes and smiled brightly. She reached toward her and said, "Mary, I am glad you are here." A resentment welled up in her that was close to tears. She withdrew from her mother's touch and said loudly, "I am not Mary, I am Loretta," and then adding softly, almost to herself, she said, "and today is my birthday."

Suddenly a change came over her mother. She straightened herself up on her pillow, looked intently at Loretta and said rationally, "Oh, I am sorry I don't have a present for you Loretta, but happy birthday Loretta, happy birthday."

She watched her mother lay back on her pillow, and into her own world of senility. She sat still trying to realize what had really happened, and then she knew. God had reached down, pulled the dark cloud away from her mother's mind just long enough to wish her a happy birthday. What a present, the best she had ever received. What stronger evidence did she need that God loved per personally. She really wasn't alone.

She stood, looked at her mother sleeping peacefully and walked out the door. She would celebrate this night by stopping at the fast food restaurant for a big hamburger, and she would never be alone again.

Saint Joseph's Croatian Catholic Church courtyard, at Twelfth and Russell Streets. Many Bosnian immigrants have passed through these gates in the past few years.

IRIS

Last spring I had an experience with some iris that confirmed the fact in my mind that there is intelligence in everything growing, and we have a connection to it.

I was a hairdresser and I worked three days a week in the shop: Thursday, Friday, and Saturday. Wednesday morning I walked out into the yard to admire my spring iris. They were so fresh and beautiful that I decided to pick some for a bouquet. I cut three of them, brought them inside, put them in a vase with water and set them on a glass table.

I stood admiring them and then a thought came to my mind, "They are so beautiful and now I have cut them, brought them in here and I will be working and gone from home for three days and the blinds will be closed, and no one here to enjoy them. I have wasted their life and beauty." As I stood looking at them I felt a sense of guilt, waste, and loss.

Sunday, the workdays over, I went into the living room, opened the blinds, and walked over to the iris, closed and drying up now. I reached out to pick up the vase to carry it out to the kitchen to dispose of the dried-up flowers. As I lifted up the vase, I saw on the glass table a perfect picture of a deep purple iris, made from the nectar that had dripped from the iris as it had dried up. It had formed exactly as it would have been painted, first a large blob of light lavender, which dried, then a small blob of deeper purple, than another smaller one of still deeper purple. It was so amazing that I ran next door to get my neighbor to confirm and enjoy it with me. Needless to say, we both came to a new realization about nature and how closely connected we really are, even to an iris that communicated with me.

The Free Bridge, c. 1920 (heading west to St. Louis from Illinois).

THE LOST GLOVE

St. Louis, Missouri, and a cold, January night, the temperature dipping down to minus-four below zero. He eased the car around the turn into Highway 55, at Broadway and Cherokee Streets, barely looking at the old landmark, De'Menil House on the left of the curve leading onto the highway.

It was past 8 p.m. It had been a long, hard day for him, actually a 12-hour day, but what else could be expected of a 36-year-old executive in one of the oldest industries in St. Louis, with almost 2,000 men under his supervision. The reason he could handle the job was because he was disciplined, dedicated, and willing to work.

Trying to do what was expected of him, trying to keep things under control by constant vigilance to solve complicated problems, but lately issues needed to be decided upon that he wasn't too sure about making, so he was waiting for the right time, or whatever.

The powerful motor of the car hummed softly as he pulled out on the highway, heading south to home and his family, a wife, and two small sons. He didn't feel the cold night. The car heater was working perfectly and he was dressed warmly. His gloved hands gripped the steering wheel holding the car firmly in his lane against the wind and blowing show, which wasn't too important anyway for his was the only car in sight going south, and no wonder. Who found it necessary to be out at four below zero on a Monday night, nobody but him.

He settled back in his seat, but not relaxing his grip on the steering wheel. He looked at his gloved hands and smiled. They were of the most expensive, soft leather, lined with the finest soft down, and they had cost $89.95 and who, in their right mind, would pay $89.95 for a pair of gloves? But he did.

His mind drifted back to another pair of gloves that had barely cost $8, and yet caused a big furor in his family by the loss of one glove, breaking up the pair, and launching a week-long search by his wife and sons of the house, garage, both cars, to no avail. One glove was lost, never to be found. It seemed, to compensate for the frustration that comes with any loss, he had bought the beautiful, soft, expensive pair and why not? He was, after all, successful by his own efforts and he felt he had earned the luxury.

A strong gust of wind made the car swerve. He gripped the steering wheel harder and turned on his highway lights. He needed all the light he could get on this dark, deserted road, tonight.

Suddenly his eye caught something in the distance, on the side of the highway, a dark spot. He leaned slightly forward as if to see better. It couldn't be, no, not a hitchhiker, and in one of the darkest places to stand.

He had an ironbound rule never to pick up a stranger, anytime. He slowed to see better, yes, it was a man standing alone, the snow swirling about him, but making no move to attract his attention, just standing there, waiting. He passed him, then stopped, put the car in reverse and backed up, leaned over and pushed the door open.

The stranger got into the car, closed the door, turned slightly toward him and said, "Thank you." He looked about 30 years old, average build, with light brown hair hanging loosely to his shoulders. Despite the lightweight apparel, with no hat or gloves, he didn't seem frozen as would be expected on a night like this. He sat quietly, watching the road ahead.

After some time, possibly feeling an explanation of some sort was due, he started talking. He had been in trouble and now desirous of a change and fresh start, he was on his way to a relative who lived in a small town in Missouri. The usual story, really saying nothing. There seemed to be a serenity about him that belied the fact that he was a troublemaker.

His turn was coming up. He dreaded to put the stranger out in the cold again. A thought came that he quickly put into words, "My turn-off is here. I'll take you home with me for a good dinner and then I'll drive you to Piedmont, Missouri, to a truck stop where

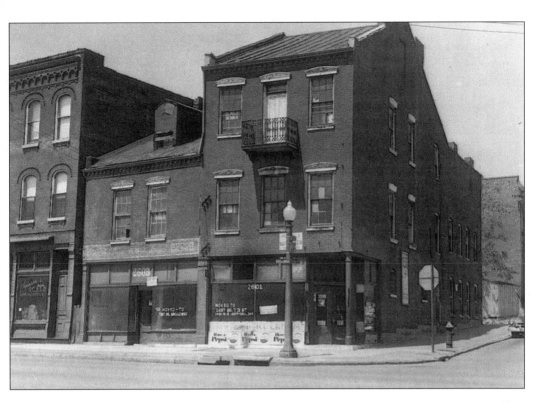

Soulard Commercial Site c. 1940.

maybe you can pick up a ride." Then, on second thought he added, "and, believe me, my family is there and if you try anything I am capable of killing you." The stranger said quietly, "I have no intention of causing trouble."

They were greeted at the door by his wife who gave the stranger a startled look, but said nothing. They sat by the fireplace with whiskies waiting for the evening meal. The stranger inquired about his work and he found himself explaining problems that he hadn't discussed with anyone. He talked on and on and as he talked, he realized he was solving long-standing problems at work by just explaining them to this man, who sat quietly listening.

His wife came into the room. The meal was ready. He felt like the mental-solving of work problems had lifted a big burden from him and he felt hungry and happy.

Back on the highway again, the late evening had developed into deadlier cold. The truck stop on the outskirts of Piedmont came into view. He pulled up by the side of the brightly-lit building, open 24 hours a day, and stopped.

With a strange heaviness of heart he faced the stranger for the last time, to say goodbye. With a sudden impulse, and as a parting gesture, he pulled his new gloves off and, offering them to the stranger said, "Goodbye and good luck." The stranger shook hands with him and was gone.

He pulled back onto the highway toward home, into the deepening cold, but he didn't mind the cold, or the ride, because he was experiencing something else, a strong feeling of confidence, in himself and his future. He knew his current work problems were solved, even though he wasn't quite sure how it had happened. Was it the

euphoric effect of the whiskey, or was it really the stranger?

He pulled up in his driveway, jumped out slamming the door behind him, confirming a quick decision not to put it in the garage for the night.

The next morning he was up as usual, regular time, regular routine. He bounded out the door into the frigid air and stopped. He had forgotten about leaving the car on the driveway and now was faced with a frozen windshield, heavily iced, and he remembered too, he had given his new gloves to the stranger. Then, a thought, the one glove from the lost pair was still in the hall closet. He ran back inside, searched through the maze of hats and other things in the upper compartment, retrieved the glove and went back outside to scrape the windshield with the one-gloved hand.

The job done, he jumped into the car, put the key in the ignition, placed his hand on the stickshift only to remove it quickly. He looked down at the lost glove hanging on the stickshift.

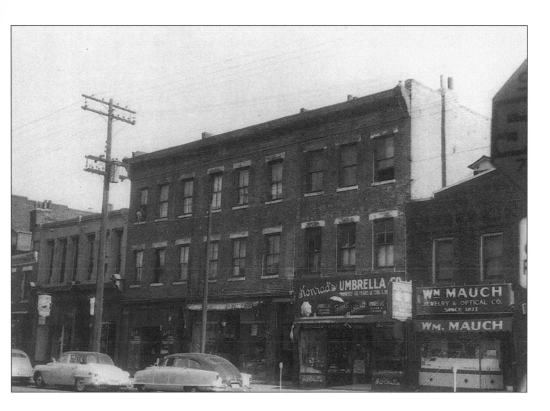

Soulard Commercial Site c. 1950.

THE ENCOUNTER
(AFTER THE WAR YEARS)

Isn't it strange that of all the countless people we meet in our lives, one occasionally leaves an indelible mark on the memory, for reasons that are hard to explain and to no particular purpose? I had such an encounter and to this day I can close my eyes and see that person distinctly, and still feel strongly that he was unexpectedly remarkable.

It was Sunday, a hot summer day Steve and I had taken a trip to a small farm in Illinois to pick peaches. There was a bumper crop that year and our car was packed with the fruit, which filled all the back seat space. On the way home, Steve, who had got hot and thirsty at the orchard, suggested stopping at a small place on the highway that served beer. I agreed but decided to sit in the car and wait for him.

I sat drowsily, with my arm resting in the open window space of the car door. A bee buzzed lazily adding to my torpid state of mind. The peaceful quiet was jarred by a voice at my elbow. "Hi!" I looked around and into the clearest of blue eyes, that belonged to a little wizened, ancient man. Despite the heat, he was, dressed for winter. He had on two overcoats, one slightly longer than the other, and a hat. A yellowed-white shirt was visible underneath these layers, and a tie. He repeated, "Hi!" and I answered, "Hi!" He asked, "Are you from St. Louis?" I answered that we were. He stood quietly, looking at me, then said, "I'm from St. Louis, too—Market Street." My mind's eye quickly produced a recollection of Market Street in downtown St. Louis. The street has been made more of a boulevard now, but in those days it was a seedy strip frequented by homeless men who were generally shrugged off by the rest of society as winos and bums.

Some were not necessarily drunkards, but

Soulard Market.

Thoroughbreds and Trotters, painted by Betty Pavlige at Fairmount Park in Illinois.

just homeless, whether by fate or their own choice. The hub of that section was a Salvation Army refuge called the Lighthouse, and it really was a beacon of light to many, with food and winter warmth. The barest necessities, but enough for survival.

I was looking at one of these men, displaced. He talked on, and explained what he was doing over in Illinois. He had a friend, a priest in a town near where we were, whom he visited each summer, hitchhiked both ways. The priest would let him stay for a week, giving him good food and a small amount of money when he left, the only money he had all year. But this year he had had bad luck. He arrived without advance notice to the priest, to find no one at home.

The priest was on leave of absence from his parish, so there was nothing left to do but get back to St. Louis and Market Street without money or food.

St. Louis was far away, and he was stranded. The blue eyes clouded as he told of the night before when he slept by the roadside, alone, hungry, and cold, even with his two overcoats. I felt ashamed of my own overabundance of wealth, more peaches than I needed, a husband inside the tavern drinking beer, a car for transportation to St. Louis, to my home. He had nothing.

I opened my bag, handed him a bill, and assured him that he could ride with us back to Market Street. Steve came jauntily out of the tavern. I got out of the car and said to him, "I

have a friend here who would like to ride to St. Louis with us. He lives on Market Street." I motioned for my friend to get into the car, to occupy the center of the front seat.

Steve wasn't agreeable with this. He knew all about Market Street. He stood, looking at both of us, towering over the overcoats—a massive man of youth and strength. There was dead silence. I looked the other way. Then abruptly he got in the car, slammed the door hard, and we started down the highway toward St. Louis.

It looked like the beginning of a long, silent ride home, but my roadside friend had unsuspected depths. The word for it now would be "charisma," but at the time I had not yet heard of that term. He was a well of wisdom, that spilled over on Steve. He knew how to relate, to entertain, to humor his audience, and there was a thread of spirituality in his stories that was like adding herbs to good soup—He was a natural teacher. His sharp wit astounded me. I sat silent. This was way out of my usual pattern of thinking. I was his inferior, and wanted to hear more and more.

Then I realized that he was paying for his ride. He was not one to take, giving nothing in return, and all he had to give was himself, his knowledge, his personality, and he was giving what he had. Steve laughed uproariously at his sharp wit, completely subdued and charmed.

St. Louis came into view, and then Market Street, much too quickly. Steve stopped at the corner of Broadway and Market and assisted our friend to the sidewalk, giving him a sack of peaches and extra money.

We drove away. With a sense of loss I looked back, but he had already been absorbed into the scene of shuffling, faceless men.

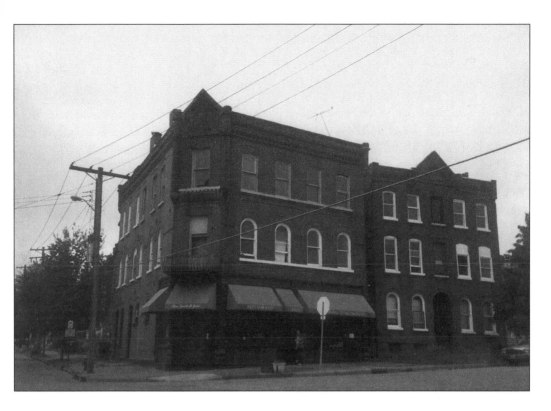

Taven-apartment combination, built in 1893 in Soulard.

OLD SAINT LOUIS
CATHEDRAL

The Old St. Louis Cathedral, the grand dame of the St. Louis riverfront, sits on the bank of the Mississippi River overshadowed by the huge shining arch. The arch, a reminder of years ago that this was the gateway to the west, the fulfilling of the dreams of countless people searching for new land, new lives, and this was their jumping-off point to the sparsely unoccupied west.

The Old Cathedral, holding the honor of Basilica, one of the seven churches in the world to hold that place, sitting serenely, quietly, housing the aura of millions of past prayers to be dispensed today to anyone who enters. January 1995, the world moving quickly into the technical age of wonders unheard of, seemingly leaving the Old Cathedral behind to sit on its old history, but unknown to anyone, she was deeply involved in the new era, the drug scene.

The dark clouds hung low, precluding a winter storm on the way as the two elderly women pulled into the parking lot for the noonday Mass. Selecting a parking spot, they pulled easily in next to a very old beige car. A young black man stooped near his front wheel, evidently examining his tire. He straightened up as the women got out of their car and greeted them with a wide smile and a cheery, "hello."

One of the women answered and said, "I see you are from Illinois by your license plate." Then, seeing a couple of round holes near his back window she put a finger in the hole and said, "Is that a bullet hole?" He laughed too and said, "Could be." They started to walk to the church. The other woman, carrying a small bottle in her hand hesitated, stopped and said to the young man, "See this bottle? I'm going into the church for some holy water. I will give you this bottle if you would like to go in and get some too."

He didn't reach for the bottle but stared at her with a puzzled expression. Realizing he was short of knowledge in that area, she said, "The holy water will protect you from harm, if you pray too. Would you like me to go in and get some for you?" He didn't move, didn't answer, just continued to look at her. She said, "I'll get some for you," and walked toward the church. As she came out she saw him waiting, not moving. He reached for the bottle, held it in his hand, looked at it and said softly, "Thank you," as she walked slowly back into the church, the only witness to the little drama, the Old Cathedral of St. Louis.

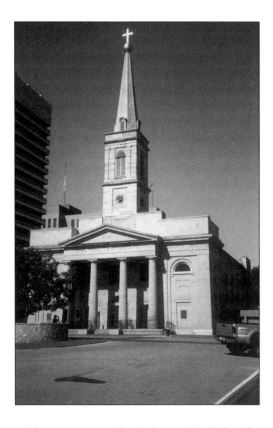

Old St. Louis Cathedral was built by the French.

Oil Painting by Betty Pavilige.

A Letter to Caroline

Dear Caroline,

I hope this finds you well and safely home again. I enjoyed your visit so much. Since you left I have a new addition to my family, a beautiful, solid-black cat. This is how it happened.

There were two young girls who moved into an apartment across the street from my Beauty Shop. They brought with them this black cat. From the beginning of their stay there, they put the cat outside, day and night, in foreign territory to fend for himself. At night he did whatever black cats do in the city at night alone, but his days were spent in the beauty shop trying, with his loving charisma, to get to be bosom pals with anyone under the hair dryers, sometimes causing rejection of him, and implications for me that they wouldn't be back if they had to hold a black cat while under the hair dryer.

This situation went on for two weeks. Then, abruptly, the girls moved, and thinking only of themselves, they left the black cat behind.

When my week's work was finished at the beauty shop on Saturday, I started for home. He stood by the door, lost and dejected. I wouldn't be back for days, I couldn't leave him. I took him home with me with plans of finding a good home for him.

We arrived home. I held him in my arms, put the key in the door, opened it, went in and put him on the floor. His feet sunk in the carpet. He stood still, surveyed the entire scene quietly, looked up at me and said, "Meow," which could have meant anything.

I went downstairs to the basement to open the windows to air out, went into the bathroom down there to shower and change clothes. He followed me in. As I started to disrobe, he jumped up on the toilet seat. I had heard of the repulsive action of cats drinking from the commode and I decided he was one of them, when suddenly he turned, fitted himself firmly on the toilet seat and went potty.

Never in my wildest imagination did I think I would have a potty-trained cat. A real gem, my black cat. I picked him up, hugged him, praised him, vowed he was worthy to be part of all my worldly possessions because he surely must have a high I.Q. in the cat world.

The days passed. We shared the same bathroom, he needing it more than I either to potty or to get a drink of water. He was the male and he dominated the bathroom. I was beginning to get that competitive feeling I'd had when I shared the bathroom with my late husband, but I was more than willing to concede, just to be in the aura of such a smart cat.

One morning I rose early, put him out in the backyard to enjoy the early morning— the birds, grass, flowers, the beginning of a new day. I went back into the kitchen to drink my morning coffee. Suddenly the air was pierced, shattered by the most awful screams. Tom was being attacked by another male who had decided this was an invasion of his territory. I raced outside, grabbed a broom on the way to help, if I could. A ferocious-looking, huge gray cat stood over Tom, who was flattened to the ground like a pancake, not fighting, not running, just enduring.

I was stunned. My beautiful black cat with the high I.Q. was a coward. I picked him up, limp from fear as black hair, chunks of it, drifted away from him to the ground.

I faced reality. He needed help, so I put him on a high protein diet, just like the athletes. Raw eggs, beef, and milk to build him up for his future with the big, ugly gray cat.

One morning as I passed a window facing the back yard, I saw a gray patch in the yard near the back door. It was the gray cat, sitting quietly, front feet folded under him, waiting.

I had an idea. I picked up Tom, went downstairs and out into the yard. He stiffened in my arms as he saw the gray cat waiting for him. I started to talk to him, "See the intruder? This is your yard, he has no business here." He growled, switched his tail,

Demolition at Soulard, date unknown.

but never made a move to leave my arms. The gray cat stood up, retreated a few yards, stood there defiantly. I kept talking to my cat, encouragingly, urgingly. He growled louder. I talked some more. He let out a piercing scream at the intruder, thrashing his tail wildly, chomping his jaws (for some reason). He screamed again, louder. He meant business, just like his ancestors from the jungle. The gray cat turned, jumped the fence and was gone. He had actually fought a verbal battle, his feet had never touched the ground, and he had won.

I was afraid to let him out alone, so many hours were spent with him in the back yard, sometimes on my lap as I sat on the patio, or watching him out of the corner of my eye as I did a little gardening. He seemed to be getting more confidence as was venturing farther and farther away from the safety of the patio and me.

I had heard a neutered cat will not roam far away so I decided on letting him have the operation for his own good. He came home from the hospital weak and limp, content to sleep around the clock, eating little.

The second day after his operation was a hot and sultry day. He stayed in bed all day avoiding any more exertion than was necessary. Late in the afternoon, the sky darkened, the air was still and close, all indications that a severe summer storm was upon us. I walked out on the patio and sat down to watch the summer scenario. He followed me, walked out into the center of the yard and sat down. The trees started to sway. The wind was getting up. He sat still looking up at the trees, evidently enjoying the approaching storm as much as I was.

The first big drops of rain started to fall. I called him. He must get inside, now. He looked at me, then casually walked to the back

Within a Soulard Market.

me, my only thought, how wet he was that minute with his fresh operation. The night wore on. I stayed up. The hours passed slowly as I peered out into the dark yard. Finally, at 3 a.m., I gave up and went to bed to sleep the sleep of total exhaustion. He was gone for good. I knew it.

The bright, high sun coming through the blinds woke me. I opened my eyes, lay still, wondered what time it was, what day it was? Then I remembered, the big storm, Tom running away. My heart sank but I would forget my loss, for my own good. I went out into the kitchen, fixed my morning coffee, made my way out front to get the morning paper. It was always under a tree and I wondered why the paper-man never hit the driveway with it. I pushed the branches aside and saw my morning paper at Tom's feet. He was sitting contentedly, bone dry, as if waiting for me to come and get the paper and him.

Well, Caroline, I suppose life is give and take even with animals. I realize I give a lot to Tom, opening and closing doors, beating up raw eggs with a fork, flushing toilets for him. Yes, I'm the giving end, but he compensates in other ways. He is such a beautiful animal. He is certainly an attribute to remind you of God's creation and love of animals too. As he sleeps on a chair in a completely relaxed position, he adds a peace and tranquility to the room and to my life.

I hope this finds you well and happy. Write when you can.

Love,
Betty

of the yard. I called, again and again, then started to run to pick him up. With a fluid, easy movement, he jumped the fence, sat still momentarily to look back at me. Our eyes met. I got the message of defiance. He walked a few yards along the top of the fence, jumped down on the other side and immediately was lost in the tall grasses of the field beyond.

He was gone, stitches and all, in the heaviest thunderstorm of the summer. I ran back to the house, the door slamming behind me with the force of torrents of heavy rain. I couldn't believe what had happened. Why did he do that? I thought cats hated water.

The hours passed, the rain continued, having only occasional let-ups, then the sky opening up to let sheets of wind swept rain hit the windows. During the let-up, I would stick my head out of the door and call again and again, not caring if my neighbors heard

St. Peter and Paul kitchen.

THE NEW WORLD OF
HOMELESSNESS

St. Louis was in for another big change, and a new word that would become part of our lives was added: homeless.

It happened gradually, then escalated. One reason was Market Street which was downtown, and downtown was being upgraded, revitalized. The homeless were out and drifted to the closest place, Soulard.

The industry era factories were declining, closing, some moving to foreign countries where workers worked for a fraction of the U.S. salaries. Jobs were lost, workers not trained to fit into the new world of technology were helpless. Unemployment checks ran out, and whole families were on the street, sleeping in cars or hastily opened shelters.

The winter of 1983-84 was bitterly cold, the young priest at St. Peter and Paul Church on Eighth and Allen saw the freezing men from Market Street and decided to do something, anything to help. One bitterly cold Saturday night, together with some young men from the parish, they got in their cars and searched the alleys, streets, the riverfront, under the bridges, for the freezing men, bringing them back and putting them in the basement of the St. Peter and Paul Church. They had a few cots and blankets. The basement was without water, electricity, heat, but they were inside, and that was the beginning of the St. Peter and Paul Homeless Shelter for men.

A homeless kitchen was hastily opened across the street in an old building manned to this day by volunteers.

The new era of homelessness quickly became part of our lives, and unfortunately escalated by a wrong political move. Some had the idea to close some of the hospital mentally ill units, and put the mentally ill in apartments, giving them a monthly check to take care of themselves. The city would have them off their hands.

Except it didn't always work out that way. Some were not capable of paying rent, utilities, medicine, buying food, and instead spent the money on unnecessary items. They eventually ended up in the homeless groups on the streets, adding burdens to the shelters and kitchens, or suffering untold pain on the streets.

I don't think the street alcoholic spends a lot of time thinking what might have been, but I know they spend a lot of time remembering past events with their family and will talk freely and at great length about it, but I have never heard one give any indication of wanting to get back to their families permanently, which I think is due to low self-esteem, but most probably, the actual fear of the loss of the alcohol that is so realistic and threatening that it erases all hope, of looking forward to anything.

St. Peter and St. Paul Catholic Church, night shelter entrance in church basement.

Soulard Today.

BARUCH

How does it feel to be homeless in a big city, and worse yet, plagued with the compulsion and pain of a progressive terminal illness, the disease of alcoholism? The early light of a new day tries to come through the low-hanging clouds overhead. He watched with little interest—the day that meant nothing to him. He waited for anything, the opportunity to catch the eye of someone walking by, and with a silent, hidden signal, ask for help, money, any amount, to help appease this driving compulsion of his body's craving for alcohol.

He ambled slowly towards a long, shed-like building in the distance, a farmer's market, called Soulard Market, the most likely place for help. A long, brick-paved walk stretched toward the building with a few scattered benches on the side. He chose a

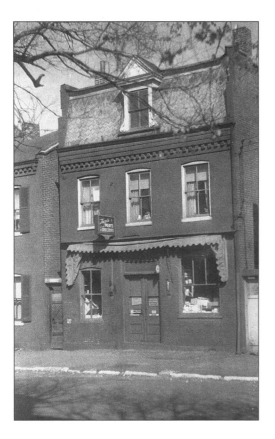

Soulard Commercial Site c. *1940.*

bench and slowly sat down. A pigeon fluttered down to the bricks in front of him, turned its head slightly to get a full view, and silently observed. The man stared back and wondered, how does a pigeon know or understand about anything. A swish of wings and another lands on the bricks, a pair, a grim reminder that he isn't a pair of anything anymore, a preference of his own choice, now made from past bad experiences. The past, despite all efforts, still surfaces in his mind, bringing with it the pain of guilt, loss, the futility of even being alive.

Much later he found out that much generosity of the spirit did not exist in the outside world for him, which made him realize his family must have loved him to tolerate so much injustice from him. To ease the hurt of the past, he brought his mind back to reality by watching the pigeons who watched him. A noise made him turn his head toward the building of the market. He tries to get eye contact and fails—the man is preoccupied. He waits. Time for him is endless.

Quiet again—the soft movement of the pigeons at his feet brings thoughts of another time, another place, other pigeons - that morning long ago.

In his room a noise had awakened him. He had laid there, then he heard it again, not the usual cooing of the pigeons on the roof, but another noise, a heart-breaking sobbing. Then the reality of the day, May 15, 1942, the sobbing was Mother. Already he was regretting his decision of joining the Army, to win the war. You won the war all right, but you started another one in your self and you lost it: The Battle of Alcoholism. It had actually started during the war, the camaraderie of friends, The good times to offset the bad times.

Living every day to the hilt, pubs, girls, alcohol (if possible) because there might not be another day. The war years, the forced acceptance of losing close friends was bad, but you had one who would never leave you, would remain at your side, be part of you,

Oil Painting by Betty Pavilige.

engulf you, solve all your problems and memories for a while, the drug of alcohol.

The last hell days of the war were endured with the only thought you could muster, to get back to your waiting friend who would erase all of this ordeal from your thoughts, for handouts to accumulate enough for a bottle of alcohol, to ease into oblivion for a while.

It is late afternoon as he makes his way slowly over Ninth Street toward the kitchen of the old landmark church, St. Peter and St. Paul Church hall, where he will have his one meal of the day, supper. He stands momentarily and looks around. Regardless of all, he still has one thing left, when his head is clear enough, an interest in food.

A gust of wind stirs up the leaves in the gutter, pulling them up into a swirling circle, almost engulfing him. He shivers. It's getting colder and the shelter has closed for the warm weather. It will open again in November. It is still early spring and the nights get cold, especially late at night on the streets.

He turns the corner on Ninth and Allen. The Parish Hall is down the street. The doors will open at 4:30. Already a crowd waits outside. He mingles in the crowd. Some say it's almost time. He doesn't know. His watch has been gone a long time ago.

The brightly lit hall is inviting, and the warm smell of food drifts out to him as he makes his way to one of the long tables and sits down. This is the highlight of the day, his

only meal, if he is sober enough to make it and, if he doesn't, it's a long wait until 4:30 the next day. He cautiously looks around at his dining companions. He is well aware that condition, age, warrants a low-key attitude, a way of life he settled down into, self-preservation, strictly noncompetitive. If some one decides he wants his place he will move. He will occupy a small space and from that post, observe and think his own private thoughts.

A painting by Betty Pavlige.

HAROLD

He shuffles along the street with no particular destination in mind as long as he doesn't get too far away from the dining hall and have to walk back at 4:30 to eat. The heavy, continuous traffic noise goes unnoticed, a familiar part of his existence, part of city-life which is his life and he accepts the familiarity as home atmosphere.

The bus stop bench comes into view down the block. He aims for it. There is no one there waiting for a bus. All the better. He arrives and slowly sits down. The early spring sun is warm. A Monday balm for quiet reverie. He folds his arms across his chest for balance, closes his eyes, lets his mind drift down and enter into the land of nod, not awake, yet not asleep. In this state of consciousness he reaches out to the only prayer he knows, just to sit and hold the stillness in him. He hears a noise and looks in the direction it comes from and sees Harold come down the sidewalk toward him. Harold, 40 or so, a huge man, still in fair condition despite his state of alcoholism. He likes Harold. He has always been kind to him, a trait lacking in so many others. Harold's quick step arouses his curiosity. Something is new.

Harold sits down, looks furtively around, even though he sees no one, he lowers his voice and says, "Look." He opens his shirt and proudly shows two long, shining butcher knives. His question, "Where..." is cut short by a shushing noise from Harold, who is seeing a market for his wares coming towards them down the sidewalk.

He walks slowly down the sidewalk, as close to the building as he can get, his fingers feeling the grooves in between the bricks as his hand slides along the wall for support. He is drunk, real drunk, at this time deserving the label "wino" except he isn't drunk on wine. It was the elite for him, Bourbon 80-proof, and it didn't take much to put him where he is. Somehow he realized it doesn't take much to make him drunk anymore, must be a reason for it, but right now he doesn't feel able to figure it out. He just feels

grateful to Harold, who generously shared his Bourbon with his latest successful venture of knives.

Harold had consumed the greater portion and now sits in a deep sleep next to a garage in an alley, exposed dangerously, because it is still daylight. He had to get away from him. He knows he can't protect him, he pushes the worry away. He will only worry about something he can do something about. He comes to the end of the block. The traffic noise indicates a busy street. He doesn't feel up to crossing it, and why, this place is good enough for the time being. He keeps his hand on the brick wall and slowly eases down with his back pressed to the building for support, and he rests on the sidewalk, sitting upright and awake, good enough for now. He forces himself to sit awake for protection. He will enjoy this euphoric state safely, if he can. Then something catches his interest. A middle-aged woman comes down the street pushing a baby stroller, but there is no baby in the stroller, it is a new dog. He remembers seeing her over the years pushing the stroller, always with a dog in it, plus other paraphernalia tucked around the dog, holding him in tightly. She stops, bends over the new small, beige colored dog, says something to him, and continues on her way. He closes his eyes temporarily to savor the moment, the place, the time, in Soulard, St. Louis, Missouri.

View of the South Entrance to Soulard Market.

CONCERT AT
SOULARD MARKET

It's an early spring Saturday morning as he makes his way slowly over Eighth Street toward Soulard Market where he will spend most of his day on the brick patio benches.

The quietness of the early morning is broken by a low, soulful humming. He recognizes the sound—Louis the drug damaged musician from New Orleans, who never really left Bourbon Street, except physically; his soul, his mind, every clear moment, back to another place, another time, that was so much a part of him.

He comes closer to the sound and he sees Louis sitting on the patio bench. Louis is a tall black man about 50 years old, wearing a much-soiled gray suit with a black shirt opened at the collar. On his head is a Russian fur hat showing indications of having been on that head a long time. His black dress shoes still carry a dull shine, indicating, even though he is homeless, he still uses the standard attire of the jazz musician.

Louis is alone, as usual. The humming is accompanied by the slow beat of slapping thighs and keeping time with his feet, while still sitting on the bench, his head swinging back and forth or side to side, coordinating the beat, enjoying a sound heard only in his own mind, his own heart. Head bent back, eyes closed, his breath creates a steam in the early morning, frosty air. He needs no one right now, nothing. It doesn't matter that he is homeless, drug-damaged, alone, because he has one priceless thing, this music within that he shares with no one, only God and himself.

He crosses the street to the patio, eases down on a bench directly across from Louis and prepares to enjoy the one-man concert, which he has heard many times before.

The beautiful humming, sometimes accompanied by a low, long moan and Louis bends his head back, eyes closed, reliving the music etched on his heart. As he listens to Louis, he feels the soul music reach out to him, arousing his own memories.

A time, long ago, New Orleans, the Mardi Gras. He was walking down Bourbon Street with a girl. It was a warm, spring night. The street was very crowded. It was a happy time. They had held hands and walked closely together. The sound of jazz music filled the air, welding the crowd as one.

They had edged closer to a corner building, a bar, and slowly made their way inside. At one end of the long room was an elevated platform that supported the musicians playing jazz. A closely-packed audience crowded together, sitting on the floor cross-legged right to the edge of the platform and reaching back to fill most of the room, having standing room only at the back.

Barmaids served the crowd, gingerly stepping over legs, feet, to find a small space to place their foot for support, everyone

A view of one of the many Soulard taverns.

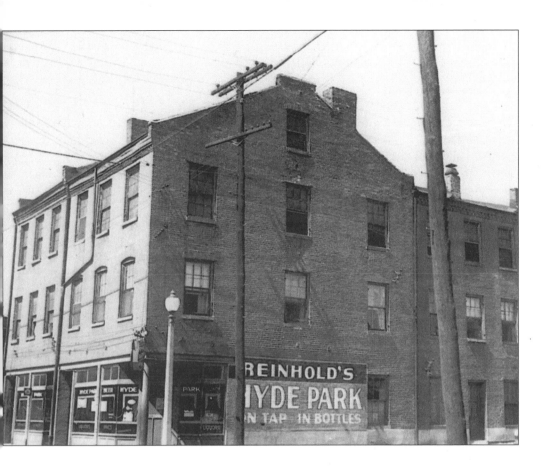

Soulard in the 1940s.

helping by passing the drinks to the center and hands passing the money back. Any effort, not too much to retain their place, to hear the music. And what music it was, seeming to be drawn right out of the souls of the players, drifting out over the heads of their audience, filling the room, spilling out the doorway to the heavy, moving crowd on Bourbon Street. This time was like no other time to be compared with.

After their drink they started walking again. The gaiety of the crowd, the effect of the alcohol, the music engulfed them.

A clown with inflated balloons on strings came closer. After much decision as to color, two choices are made: a red one for him, a yellow one for her. She holds the string, laughs, reaches up and kisses him.

Farther down, a girl on a swing is swinging out of a building window, then disappearing back into it, back and forth, over the heads of the crowd, laughing, waving, making everyone wish it was them, instead of her.

So much to see, costumes depicting various eras, times, foods of all kinds being sold, some from small stores, some from hucksters on the street. Shrimp, fish cooked in various ways, the traditional gumbo, rice, beans. An oyster bar comes into view, very crowded, the observance of some holding paper containers filled with raw oysters, then selecting one and gulping it down.

A silence jolts him back to reality. The humming has stopped. He opens his eyes. Two men are bending over Louis, talking, while handing him a pamphlet. Louis bends

forward politely to hear better, with no indication of dissatisfaction at the interruption.

They walk away. Louis turns the pamphlet over and over in his hands, not bothering to read it. For a while his own imagination had let him soar above the sordid reality that surrounded him and now he was back. He stood, straightened his back up and walked slowly over to the trash can and dropped the pamphlet in.

Menard Street scene.

THE TRIP TO ATLANTA

It was a dark, cold, rainy day with a raw wind. After a mild winter, March had come in like a lion and was still roaring. The homeless kitchen at St. Peter and Paul had a warm, happy atmosphere as the volunteers, the faculty, and some students from Webster University, prepared the evening meal to be served at 5 p.m.

Anna Barbara, the director of the group saw the homeless coming one by one and huddling in the rain next to the building outside. Lowering her rule, she opened the door and invited them in to wait in the dining room until serving time. They sat quietly, glad for the warmth.

The toilets that served everyone were located at the end of the dining room. As it came closer to serving time, I decided to made a last trip there.

I noticed a young black man, about 25 years old, sitting at the last table looking at a white paper, at his side was a large shopping bag, indicating he was a street person.

As I started back to the kitchen, he called, "Lady, can you please help me with this." He handed the white paper to me. He said, "It's a ticket to Atlanta. I wanted to know if it is expired."

I looked at it but wanted to have it checked again by someone else too.

Going back to the kitchen I showed it to Anna Barbara who said, "It expires today," then showed it to her husband, Ed (a Ph.D math teacher), who quickly scanned it and said, "March 16th, expires today."

I went back to the young man and said, "It expires today," which seemed to excite him as he rose in his chair to leave. I said, "We serve in a minute, wait and eat, it won't take long."

The serving began, the lunches filled and served by quick, young students, then quietness over the dining room as they ate. The young man stood at the door to the kitchen with his large shopping bag, indicating he was leaving, but asking if we had a larger bag so his clothes wouldn't get wet.

Someone found a large, white trash bag and Anna Barbara quickly filled a small bag of meat, bread, and cookies, for his trip. He put his shopping bag inside the trash bag and tied it together in a way to form a handle of a sort.

As he bent on his work, I said, "Are you going to see your mother in Atlanta?" He stopped, straightened up and looked at me intently and said, "My mother died 17 years ago." Then he resumed his work. Somehow I felt stunned because I realized the 8-year-old motherless boy had not fared well. He couldn't read or write and now at 25 he was on the street. No, he had not fared well at all.

He straightened up, picked up his trash bag suitcase and said, "I thank all of you, I really appreciate it," and started walking down the hall to the outside door, out into the raw, windy, rainy day, but leaving a part of himself behind at the homeless kitchen of the St. Peter and Paul Church.

Rehabbing at Soulard's North End.

THE ROSE

The soup kitchen entrance at St. Vincent's Catholic Church in Soulard.

He sat down looked at his cake with the rose on it smiled to himself quietly and, for a brief minute was back to another time earlier in his life when he was loved and happy with a home, family, and a birthday party with a cake with a rose on it.

It was a bitterly cold day in the dead of winter. The homeless kitchen was crowded and quiet. The shelter was filled to capacity for the night. A lot of men would have to spend the night out which probably accounted for the quiet, a worry for many.

The hot dog on bun and pork and beans provided a hot heavy meal, and decorated birthday cakes donated by a bakery where they were ordered and not picked up.

The meal over, the volunteers carried the tray of cake cut into squares in front her table and started to place a square in front of each person. Suddenly across the table a young white man in his early 20s stood up, the street grime on him and his clothes marking him a person on the street. He said loudly "Lady can I have a piece with the rose on it?" Startled, the volunteer didn't answer just quickly handed him the one that he pointed to.

Lafayette School in Soulard.

ANNA OF SOULARD

He was lying on his back when he opened his eyes to the new day that was still dark.

The clock on the dresser said 10 minutes of 6 a.m. He lay still momentarily, then, still in the same position, crossed his body with a sign of the cross and said aloud, "In the name of the Father, the Son, the Holy Spirit," and proceeded to say his daily morning prayers, thanking God for this day, and hoping his actions this day would be pleasing to Him.

His prayers finished, he got out of bed, dressed in the still-darkened room, and walked to the front room of his small apartment and peered through the blinds to the small yard in front of his building. He smiled as he saw the morning paper there. He thought the prompt, always punctual paper-man was indeed a great blessing in his life. His morning coffee and his newspaper, a winning combination in his life.

He turned first to the sport section, intent on this day's selection at Fairmount Race

Thoroughbreds and Trotters, painted by Betty Pavlige at Fairmount Park in Illinois.

Track. He took mental notes, in case the weather or his mood would permit him to go to the evening races. Then, turning the pages, he came to the great love of his life, the real big gamble, the financial page and the stock market. He spread the page flat on the table and proceeded with this morning's work. He scrutinized every line carefully to see what stock had gone up, and what had gone down since yesterday, and to decide which to move, which to keep, if any, today.

His analytical mind screened every line carefully, his almost photographic memory comparing notes to yesterday's closing. The morning moved on, still he pondered, calculated, then made decisions. Finally, the job completed, he raised his head from the paper, stood stretching his arms over his head to offset the cramped condition he had been in for almost three hours. He closed his eyes, moved his head from side to side, stretched his neck, ah, that felt better. Glancing at the clock to check his time, he went to the phone to call his stock broker.

The morning sun was high as he emerged from his apartment and walked down the front steps to meet his 70ish-year-old neighbor, Anna, who was sweeping the white stone steps that led to her Soulard apartment. She greeted him with a cheery, "Good morning," and added, "Off again, are you," shaking her head in a negative fashion to emphasize her feelings, unsaid, that she felt he wasted his time, instead of sweeping his own front steps.

Anna was super clean, and she expected her neighbors to spend a sensible, allotted time each day to that task, and this neighbor fell far under expectations in that field. She also felt he fell far under expectations in another field, too. He frequented the races at Fairmount Race Track, coming home sometimes late at night, and, she imagined, a loser. She reasoned and she had heard nobody beats the horses, but she kept her feelings to herself on that matter, most of the time, feeling a compassion for him. He did have winning ways, and sometimes she shared her rich soups with him, or her marvelous strudel, or her fine roasts, for she was a good cook. She felt by sharing her food she was feeding a poor neighbor who spent his pension at the track and ran short on the food supply. She knew he didn't cook. His stove was piled high with old newspapers, making the cluttered apartment look more cluttered.

She had offered many times to clean his apartment, free, just to help him, but he had smiled I and very often, because the clutter made her extremely nervous, almost like a helpless feeling, as she couldn't understand how he could live in such disorder.

He walked slowly down the bricked sidewalk, turning east, at the corner and going down to the wide street called Broadway. He carefully crossed the wide, busy street, joining others at the bus stop on the other side. The sun was warm, even though it was January. The soft breeze wafted a familiar chemical odor to his nostrils, because they were only blocks from Monsanto Chemical Company, one of the largest in the world. The odor was not offensive to him for one reason—it reminded him that Monsanto stock paid big dividends, and he was one of their stockholders.

The others at the bus stop evidently were not stockholders, one man going so far as to spit on the ground to show his offense at being compelled to live with such an odor, not bothering to face the fact that Monsanto didn't force him to live there. He did that of his own accord. A younger man in the group, evidently an employee of Monsanto, now off duty, felt compelled to defend the company where he made his living and said loudly, "That odor isn't coming from Monsanto, it's from Busch's Brewery." Then he hurriedly jumped, the first one on the bus that had arrived, so that he wouldn't have to hear an adverse comment from the older man.

He waited until all had boarded then stepped up and entered the bus, going all the way to the rear and selecting an empty

Thoroughbreds and Trotters, painted by Betty Pavlige at Fairmount Park in Illinois.

eat into which he sat heavily, close to the window, folded his arms across his chest and closed his eyes to the discord, the negative feelings that had cut into his happy day, a condition that would not be a part of his life, simply because he would not let it be so. The bus started, stopped, then continued on the usual route. He mentally counted the starts, stops, then opened his eyes to Olive Street, his stop.

He slowly made his way up Olive, stopping at Miss Hulling's cafeteria for his usual hearty breakfast. He liked the atmosphere of the cafeteria, all business, no personal involvement in any way, giving him free time to enjoy his meal alone, to think his own thoughts for a while over good, fresh food which would be his only meal until dinner, wherever he would be at that time.

His meal over, he walked slowly west on Olive, his usual route, his destination the public library. It was a number of blocks away, but gave himself a chance for physical exercise, plus enjoying the busy city life, the comings and goings of people who evidently didn't have the time to saunter slowly along as he did to enjoy the air, the walk, before he started to climb the long steps to the top. He was undecided who he would like to be with the next few hours. This was a very important decision he made every day. The library housed the thoughts and feelings of countless individuals, some long since gone from the earth, but who had left behind in books a legacy of their own personalities, and all he had to do each day was select one he would like to spend a few hours with.

Yesterday, he had selected a manual on electrical engineering and found startling new information. The world was moving on

Thoroughbreds and Trotters, painted by Betty Pavlige at Fairmount Park in Illinois.

fast, gaining more scientific knowledge, technology amazing facts that had kept him spellbound yesterday, until he had stayed way past his usual time and didn't even go to the track. Today he would cool it a little, pick up something he could leave easier, at least give himself time for a good dinner and then go to the track. His time was precious, so taken up, he had to constantly remind himself to be aware of time, or the day was gone.

The thought of time quickly brought back to his mind a book he had read earlier in the week, and it had a strong impact on his mind, because it was so exciting that his thoughts went back to it again and again. It was a book written by the Nobel prize winner, Hannes Alven, who was on the faculty of the University of California. His ideas of the cosmos are that outer space may

be made up of immense walls of electrical currents that are divided into cells, the same as cells make up human life, animal life, grass, trees, flowers, and these cells may separate outer space matter from anti-matter. There could be times when these cells spring leaks, and matter and anti-matter clash and explode and cause vast amounts of radiation. The idea of the outer space made up of cells and electrical currents controlling them was ignored by other scientists as fiction, but his ideas were finally vindicated, winning him the Nobel prize in 1970.

He started up the long steps slowly, his thoughts on outer space. He had spent his life as an electrical engineer, and he knew the conception of outer space being made up of cells and controlled electrically had never been thought of until this man came up with the idea, and of course why wouldn't it be

so? God created earth and everything in it by cell formation, and why wouldn't He create outer space the same way, with the cell pattern the same as other things He created.

He thought it sounded like good, common sense, and he wondered why someone hadn't thought of it before. He stopped, looked up again except in wonderment at God's creation, and the way He did it.

The odor of the library was pleasing to him, soothing, and he entered and chose an aisle he dearly loved, psychology, but who would he spend it with today? His fingers followed his eyes as he lovingly touched book after book and finally made his selection: Thoele, the German philosopher.

Despite his resolution to leave early, it was dusk as he came out of the library, stood on the porch, momentarily, enjoying the scene before him, the lights adding a warmth to the busy city of people going home after work. An unusually strong cold gust of wind slammed against him, jarring him back to the reality of the moment, and a remembrance it was January and there were unpredictable weather patterns familiar in St. Louis in any season. He descended the steps, turned east toward dinner, home or the track. He looked at his watch. It was too late for a leisurely dinner. The food at the track was good and he smiled to himself, enjoying the pleasure of the thought of spending an evening there.

The race track bus pulled up to the gate, and he descended into a strong, cold, gusty air. The weather was changing fast, but it didn't matter to him. It was warm inside.

The clubhouse was the usual atmosphere, busy, detached, happy with the anticipation of the evening and, of course, success. He walked past the new Amote system recently installed, computerized, indicating progress even at the track. He liked that. He liked progress, a better way of doing anything,

Thoroughbreds and Trotters, painted by Betty Pavlige at Fairmount Park in Illinois.

because in some way it made a man's life on earth easier and, heaven knows, man had difficult times in the past. He grabbed the first empty track chair he saw, and dragging it along. He arrived at the usual spot he sat, indicating he was a man of habit.

It was already occupied by his friends, his clique at the track—two men, also creatures of habit, sitting at the same spot each time they attended the track. He had heard that people do the same thing in church, sit in the same pew week after week. He was greeted warmly by his friends who then sank their heads back into the form, the program, comparing, studying, planning. He had been their contemporary at the track for a number of years, meeting them, spending the evening with them in a compatible comradeship, and yet he knew very little about their personal lives except in this latter stage of their lives. They were alone, or almost, living on limited amounts of income, their pensions earned as laborers, and now they were trying to increase their income, plus enjoy an evening out, by winning a little money at the track. If they lost, he would not see them for a while until they recouped their finances to allow another trip to the track to try to win again. He had felt a hurt for them when he knew they had lost and yet they still retained their humor by saying, "The pay window is that way," pointing and laughing as he had started toward the window to collect a ticket when they had lost. It was their way of laughing at themselves.

His day had been so full he hadn't heard a weather forecast, but he didn't need one as he looked out on the track through the immense windows. The wind was up and a light snow was falling, being blown in all directions as the wind changed constantly. As he continued to look out the window one of his friends said, "Air, all the way from Canada, and it's cold and going to get colder, the forecast said."

Then the announcer, "Due to the cold, there will be no post parade." A protection for the horses, he knew, and a procedure used only in extreme weather. He settled himself to pick a daily double, a must it seemed for everyone, and a decision to go with the favorites, the names, the records of wins, the money they had won over the years, the places, the shows, or just the psychic feeling of what name appeals to you the most, like to remind you of something, a connection of some sort, which added up to just plain superstition, or to look at long shots and what did you feel when you looked at the odds. Was it possible, the name, did it have a strong pull at your feelings, or was that just your imagination? Then to pick, hurry to the window, place Your bet, or change your mind at the last minute and place something else, but to place your bet, walk away, say the hell with it, and hope for the best.

His friends walked to the window separately, placed their bets, sat down again. He wondered what they had bet, but didn't ask. He really didn't want to know. He walked over, placed his bet, came back and sat down, and sat looking at his program. He thought, "Isn't it strange, I manipulate large sums of money each day at the stock market, and yet a few dollars spent at the track upsets me. Why?" Suddenly, he knew why—his friends. He looked at them and felt a compassion and hurt for them, because of their limited income and how they really wanted to win. It meant so much to them to win.

In his own case, he really didn't care one way or the other. To him it was a night out and the fun of a friendly, harmless wager. He knew he could have gone overboard and bet a lot to win, but it wasn't necessary, his big gamble was early in the morning, the stock market, and the track was to him just harmless fun, gambling.

He remembered he had missed his evening meal. He walked to the concession stand, ordered three beef sandwiches and coffee, and brought the tray back to be enjoyed by all. They reluctantly accepted, but

Thoroughbreds and Trotters, painted by Betty Pavlige at Fairmount Park in Illinois.

then agreed and indulged, thoroughly enjoying the enormous sandwiches and coffee.

Was this on the horses? He must have a sure thing, the races hadn't even started. He smiled, happy to see them enjoy the food and remarked, "It was really a postdated meal on winning from sometime back," which made them enjoy the freedom of worry even more, as they believed he was on their own economical status.

The fourth race was coming up. He had done fairly well so far, but his companions hadn't collected a ticket. He didn't want to offer a suggestion which could very well prove wrong, but he wanted them to win too, so he said, "I like this number four, Flying Marcia." Without looking up, they

agreed it was a good choice. He went to the window and made his bet: win and place on Flying Marcia, the place bet to back up the win, in case it didn't win, and sat down and waited.

He looked out the window, waited for the race to run. The wind whipped a fine snow and dirt, in a swirling arc that lay close to the ground, then rose higher and higher and was lost in the atmosphere, only to be replaced by another on the ground. He watched from inside the warm clubhouse, not realizing the weather was quickly changing into a dangerous pattern for all. He enjoyed watching the wind and some of the brave souls who ventured out into the yard, hunched up, braced against the cold, intent on watching the race run and seeing

firsthand their positions as they came over the finish line. He felt very happy, very content. He liked the races, liked his friends and their happy dispositions. They returned to their chairs, sat down and waited for the race to run. Then, "They're off!"

He watched through the window as far as he could see. They were on the stretch, around the turn, on their way home. He automatically stood, straining to see, and it was Flying Marcia. She had won. He watched the board across the track, waiting to see what it would pay before he went to collect. It flashed on, $10.40 to win, $6.80 to place. He had won $17.20. He started to the window. His friends made no move. He knew they had lost again.

The races came, went, and coldness crept into the warm clubhouse, causing him to shiver and go back to the concession stand for more hot coffee which he offered to buy for his losing friends, but they didn't accept his offer, and instead said they were going to start for home. He would remain alone. He had come on the bus and he would have to go back on it, so he really had no choice but he didn't mind. He liked to stay for the entire race, even if he did get home late. It didn't matter. His time, his actions were just to please himself, and they fully occupied every minute. The evenings passed, sometimes too quickly.

The 10th race was up—the trifecta. He decided, since he was a winner tonight, to box a bet, which meant to pick three numbers, and if the three came in, they could win in any position. The boxing cost $12.00. If he would pick the same three numbers for a $2.00 bet and not box them, they would have to come in exactly as they were picked, to win, place, show, and it could be very disheartening to pick three numbers, and they came in, as you had bet them and lose. That had happened to him a long time ago, and that trifecta had paid over $6,000, and he had lost due to the fact they weren't positioned right on the ticket. He vowed he would never bet the trifecta again unless he

boxed it, and, if he had a losing evening, he just wouldn't bet at all, because the $12.00 wasn't worth the disillusionment. He made his choice, started toward the betting window, when suddenly, the sharpest, most agonizing pain he had ever felt in his life burned in his chest. He stopped, luckily near a post which he leaned against, and stood still, unable to breathe, sounds and lights fading away then returning.

Forcing himself to bear the pain and not cry out, he closed his eyes and pressed against the post. Gradually, the pain eased. He waited, camouflaged it well, but now he felt weak. With trembling legs he slowly made his way towards the exit door and the waiting bus, he knew would be there by now. The trifecta was forgotten, not needed or wanted. All he wanted was to get on the bus, sit down, regroup himself back to normal.

As he walked out the door, a severely cold gust of wind blasted down at him, making his struggle toward the waiting bus even more difficult. The bus driver opened the door for him to get on, and hurriedly closed it after him, keeping the cold air out until someone else came. He walked to the rear of the bus and sat down, closed his eyes to relax and to think. What should he do? He had read about severe chest pains sometimes indicating a heart attack, then again, maybe it was a muscle spasm. At any rate, it was gone now, but he couldn't believe the weakness he felt, and he wished he was home in bed.

Anna turned her radio on to get the early morning weather report. She sat at her kitchen table, holding her coffee cup with both hands to absorb the warmth. This was sure a cold Sunday morning, and she would wait to see what the weather report was before she dressed for church. She would dress accordingly, because she had four long blocks to walk. She was on her second cup of coffee before it was announced "15 below zero," breaking a record. She couldn't remember it ever being that low. She wondered if she heard right. She waited, he repeated again, "15 below zero," and

cautioned that the wind-chill factor could cause frostbite quickly, and everyone who didn't have to go out should stay home, inside, where it was warm and avoid the danger. She listened, leaning forward to catch every word. Chicago had 26 below. The whole nation was engulfed in this terrible winter storm, some having tremendous amounts of snow, and she felt grateful it wasn't St. Louis.

She thought of her neighbor. She had heard him come home late last night, probably from the races, as usual, heard him close the door, and she had silently thanked God that he was home safe again as she lay listening to the howling wind that had brought all the cold air in from the top of the world.

For some unknown reason, an uneasiness came over her. She put her heavy sweater on, pulled a cap over her head and went to knock on his door. There was no answer. She knocked harder. There was only a cold silence. She thought, "Maybe I will offend him by coming over so early. I'll come back later." She returned to her kitchen, sat down and waited for time to pass, so she could go back. She sat rigidly, hands clamped together in her lap. She started to tremble. She had only one thought, she knocked on that door again, waited, then losing all control she pounded with both fists, screaming his name, to silence, and the bitter cold.

The late afternoon sun streamed unnoticed through the window and fell on

Thoroughbreds and Trotters, painted by Betty Pavlige at Fairmount Park in Illinois.

the letter she was reading, a letter she couldn't quite understand, so she read it again and again. It was from the attorney of her neighbor, the late Robert L. Blumn. He was requesting her presence in his office in regard to the estate of the late Mr. Blumn.

A sadness came over her, and she wondered what kind of a state of affairs he had left behind, since he did frequent the races often. His passing had left a deep void inside her, a void she tried to fill with her usual cleaning and cooking, but her heart was heavy. She missed him and his sudden death had taken a toll of her. She hadn't felt like herself since, and the passing time didn't seem to be relieving her empty feeling. She laid the letter aside, went to the window and looked out, not really seeing anything. She thought, "Maybe he has left unpaid debts, due to his gambling," and then she thought, "If he has, I have a little money. I'll offer to pay them, so that he has died honorably, debt free. I'll repay him for his kindness to me," and she cried softly.

The bus clamored, stopping, starting, jostling her, the bus fumes seeping in some places, reaching her nostrils, making her feel nauseous.

She looked out the window to a scene she wasn't seeing. Her thoughts were elsewhere. She clutched her bag close to her body, the bag that held her savings account book, showing $3,200. A worry clouded her mind as she realized she might not have a savings account anymore, her savings that had been a strong point in her confidence in herself in her later years, but then there were more important things in life than money, and one of them was honesty, to always pay your bills as soon as they arrived, a practice that had been part of her life. She thought of her neighbor and she knew she had to do what she was on her way to do, clear his debts, let him rest in peace, for she knew he was a good, honest man, maybe weak, in many ways, and a happy feeling came over her as she remembered a day long past. It had been her birthday but, since she had no relatives

it, was a day that always went unnoticed, because she never mentioned it to anyone, and why should she . . . friends weren't responsible for her birthday, so the day always went disregarded except to recall memories of her childhood and her parents, and the cake with candles and the love they gave her.

She had been sweeping her steps and walk, and then proceeded to sweep his as he came down his steps going out for his daily trip to wherever he went. He said, "Good morning, I see you are busy already." She stopped sweeping, looked at him and startled herself by blurting out, "Yes, and on my birthday, too." She turned quickly, because for some reason tears rushed to her eyes, and she couldn't let him see that, so she hurriedly walked away from him. He didn't answer. He stood still, looking at her, then went out the gate, and slowly walked toward his bus.

She felt ashamed that she had acted so foolishly, and thought, why didn't I say, "Yes, and it's a beautiful day." That would have been a normal way to act, and yet she knew in her heart she had wanted him to know it was her birthday, for no reason, she just wanted to share the thought with him. He hadn't even answered, not even to wish her a happy birthday. She remembered she had kept busy the whole day. She always felt in better spirits when she scrubbed and waxed her kitchen floor, cleaned the windows until they glistened, put up curtains and then stood back and admired her accomplishment.

Later in the afternoon, there was a knock at her door. A young man with a huge, long white box, stood before her. He looked at a ticket, repeated her name and said, "This is for you." She said, "I didn't order anything." He said, "It was ordered for that name," shoved the box into her hands and walked away. She closed the door and with trembling hands opened the box to the most beautiful sight she had ever seen in her life— 25 long stemmed, yellow roses. She felt spellbound by their beauty and thought

there is surely a mistake somewhere. Her eyes fell on the pink card that dangled by the string that had been tied to the box. She opened the card that read: "To Anna, Happy Birthday, Robert L. Blumn."

The bus lurched and she came back to reality. Then it stopped. She got off, stood momentarily and, looked up to be sure she was at the right place, a tall, new building in the heart of downtown St. Louis. She walked in, scanned the names of the directory on the wall, walked to the elevator and pushed the button for the sixth floor. The elevator door opened and she stepped out into a huge office area, so lavish it almost overwhelmed her. There was a desk with a beautiful, young girl who looked up and said, "Yes?"

She was ushered across the room, through a door, into the private office of the attorney who had sent the letter to her. She wasn't the only one in the room. There were others, all men. She was the only woman. She was startled to see her parish priest, Father Moore, who smiled at her and said, "Hello, Anna." She felt almost ashamed to look at the priest as she thought, "Did he owe money to him, too?" She glanced at the others in the room. She realized what a really small amount her savings was to pay all these people. A fear crept over her. She felt defeated, and she hadn't even begun.

After some time, a rear door to the office opened, and a gray-haired, smiling, distinguished, middle-aged man came in. His very being upon entrance emulated success, confidence, security, charisma, everything that made her feel worse and less. He picked up a sheath of papers and held them in his hand, his eyes looking at each one in the room, individually before he spoke. He waited. The atmosphere in the room thickened, became almost heavy, then he began to speak.

He explained that Mr. Blumn had selected him to be administrator of his estate, and everyone summoned in this room was a beneficiary. Anna felt faint. Her eyes were glued to his face, trying to almost search his soul. Could she be hearing right? He started at the end of the circle. Father Moore, his parish would be a beneficiary. The next two representatives were from Washington University, the next two from St. Louis University School of Medicine. The next man represented a small trade school in Chicago. Anna sat frozen, unbelieving. Then, the last two men, the friends from the race track, who sat dumfounded their faces showing disbelief as they had thought their friend was of their own economic status.

The attorney went on. The only personal attribution he specified in his will was for Anna. He put his glasses on, turned the pages of the sheath of papers and read, "To Anna, who in my estimation represents a woman with highest honor, virtue, and integrity, I leave her one-sixth of my estate so she can be taken care of financially for the rest of her life." He removed his glasses, hesitated as everyone in the room leaned forward to catch every word.

He continued, "The rest will be distributed among you as he requested. The amount of the estate of the late Mr. Blumn is one $1,400,000.

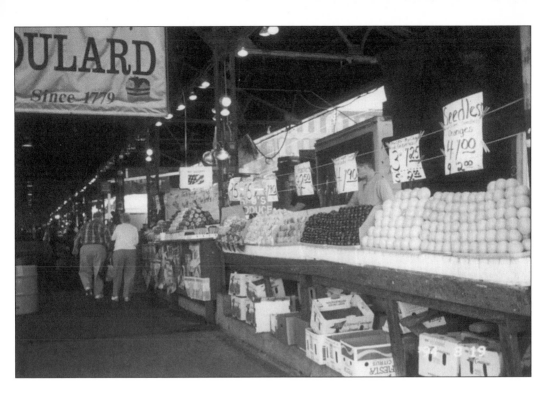

Soulard Market.

ANASTASIA

Of all the remarkable people whose destinies had brought them or their parents from many parts of the world to become residents of the Soulard neighborhood, I believe that one of the most extravagant was my mother-in-law, Anastasia Paslisz. At the age of 17 I had married her 20-year-old son, Steve, whose last name had been somewhat anglicized to Pavlige. I encountered concrete opposition from her at every turn. We seemed to have nothing in common but Steve, and in matters such as those that benefit from family consensus, we were opposites. She was a huge Russian woman, possibly over 6-feet tall. Her black hair was pulled back in the traditional bun revealing clear skin and even features. At times she wore a head scarf tied under her chin. In Russia, she said, this signified the married state. A scarf tied at the back of the head denoted a single woman. She spoke no English and I spoke no Russian, a shortcoming on my part that seemed to amount to a cardinal sin. Another sin was my contrast to her and her son, both of whom were overweight. I soon learned the word *Kabasa*, which meant me, a sausage.

She ruled her four sons with an iron hand, and I was terrified of her. She didn't hesitate to use physical force on all including the two sons in Cardinal Minor Baseball League. They were special targets of her wrath, running around playing ball, and not holding salary jobs like normal people. She couldn't read the papers, and they didn't bother to tell her that playing professional baseball had prosperous possibilities.

The greatest difference between us was that she could cook. She seemed to fear that her son would soon starve to death with me, and there she had a point, my culinary triumph being along the line of fried potatoes and jello. As the personality of the artist shows in the painting, so her personality was evident in her food, heavy, rich, as inexplicable as she was.

As I ate her food in silence, I realized that her two baseball playing sons must have got the strength to pitch their countless no-hit games, of which she was completely unaware, from her heavy protein meals. Her marvelous chicken soup made only with large, fat, heavy hens was seasoned with that rare ingredient, parsley root, found at Soulard Market, on a Saturday morning. She explained, through my interpreter, that fryers couldn't be used for soup, that the meat of the heavy chicken contained fluids and gelatin which released in the soup produced hearty broth.

With her borsht, she cooked a large piece of beef and into each bowl dropped a blob of sour cream to counteract the sweet taste of the red beets. It was superb, rich, red soup. The piece of beef was removed from the soup, placed on a platter and sliced for sandwiches on Jewish rye bread with horseradish. She would place a head of lettuce on a plate, the servings torn off at

Betty Pavlige.

Anastasia and daughter-in-law Aline.

Rehabilitation work being done at mid-19th century buildings in Soulard.

will, sans salad dressing, a large bowl of fruit and nuts for dessert, the perfect meal.

Her skill at the cook stove wasn't confined to soup. The traditional Russian dishes were complicated, requiring a long time for me to understand the technique. My obstacle was mainly the language barrier, at home, the interpreter usually ending up as the cook.

I had nothing to give her in return for the marvelous recipes except the English language which she decided to learn and did with seemingly effortless speed. It was not effortless, she explained. It had been very difficult for her to learn English because it was so different from the other five languages she spoke. This amazing, illiterate woman was, now speaking six languages, and yet she was unable to read or write any of them. It was much later when I learned the full story.

Her world and ours was in for a big change, all bad. The war was coming and the draft. At that time, military enlistments were offered for one year. Join for one year and your time would be in, your duty done.

It was Sunday at her home. The four sons were arguing among themselves about the decisions, to join or wait. The youngest ball player decided he would accept the one year and then come back to the minors. At his age, he argued, one year couldn't hurt his arm. He joined and was gone five years. By then his arm had lost its snap and his baseball career was over. The interpreter son would wait as would the other two.

The wait ended in March of 1943. The dreaded letter, "Greetings from the President of the United States," that so many jokes had been made about, arrived. The jokes seemed sour now, not funny at all. Steve selected the Navy because he could swim and he thought the food might be better.

The day came for him to leave. He walked to his mother's home. She would go with us to Union Station so he could catch his train. As Steve and I started up the steps to her flat, the air was filled with the sound of loud sobbing and wailing, so heartbreaking, I was overwhelmed and hesitated going the rest of the way with him. As we walked in the door the sounds abruptly ended. She then spoke in her native Russian tongue, which I could not understand, to have him close to her, alone, in this last hour. It didn't matter to me, for there was nothing I could do to help.

She had cooked his favorite food, a rich potato cheese dumpling for possibly his last meal with her. She piled his plate high, pouring a large amount of melted butter over the mass, and all the time speaking softly, soothingly to him in Russian, this one who had been born of her at home, at the same time a man was white-washing the kitchen walls. It was an inopportune time for him to be born, with the house in turmoil and she had told him often about the trouble he had caused her by just being born. Then

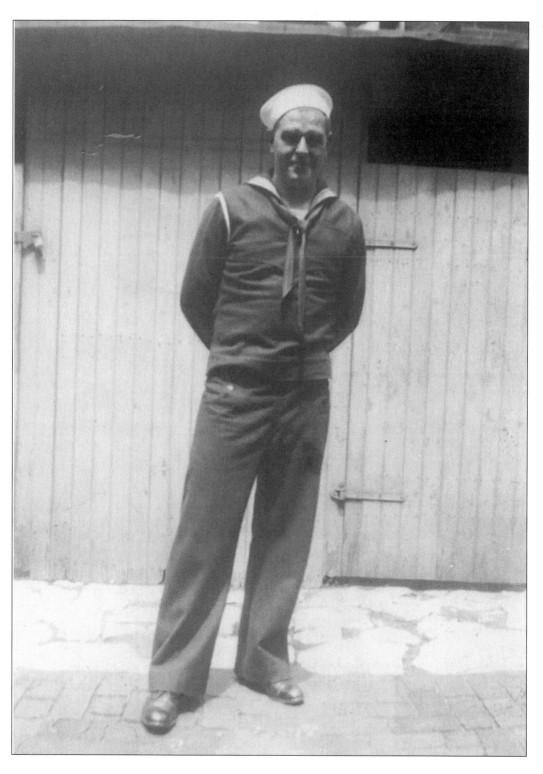

Steve Pavlige.

the hour was over and we left. He was gone for the duration.

Letters came regularly to me but not to her. Heartless? I'm sure he didn't mean it that way. He knew she couldn't read so he didn't bother. I explained to her that he would include his letters to her in mine so that I could read them to her. She accepted the idea so I read them to her. I left out the romantic parts and quickly added paragraphs about her that I made up. Was she well? Was she taking care of herself? He missed her, her food, she should join the Navy and show them how to cook. This would bring uproarious laughter, and sins on my soul for lying.

I saw her often and one day she asked me if I prayed for his safety and return. She had caught me off-guard and I quickly answered, "No," which was the truth. It actually had never occurred to me. She just looked at me,

Gangways between buildings in Soulard.

I think she had come to the realization that she should not expect too much from me.

The war was going badly for us. There was a possibility we could lose. I was worried and so was she.

One dark, dreary Sunday she came to my home. She talked, on and on, telling her story. She was one of 11 children. They lived in a village with buildings made of packed mud, thatched roofs, and dirt floors. The 30 degree-below winters were hard. Many died of the cold. Food became scarce and meat once a year was about all that could be hoped for. The diet was mostly potatoes, millet, cabbage, and sour cream on occasion. She remembered bad food, bad times, no schooling, the revolutionaries, called the Bolsheviks, forming to overcome the Czar. He was a bad man she said, living richly with fabulous treasures and people starving. History has proved that she knew what she was talking about.

She decided to leave home as soon as possible, and at a very early age she did, walking to other villages seeking employment, enough for food and lodging. Then on to Bremen, Germany, a prosperous area, finding work in a factory. She quickly learned the German language out of necessity, then Polish from co-workers, and other languages when necessary. The similarity of the languages of the close knit Balkan countries made communication fairly easy. She saved money. She had a goal. She would go to the United States.

When she had the necessary amount of money, she made the arrangements and boarded a ship, lower class, for the United States. She was completely alone, never to return to her homeland except in her thoughts, never again to see any of her people except her two younger brothers in later years when she had saved money for their passage to this country. She had never heard of the sea-sickness she encountered, and was prostrated for the early part of the trip, the basket of bread and sausage she had carried on her arm going untouched for days.

The Soulard commercial area, c. 1950

Then she began to rally and mingle with others making friends with a Polish family. She was feeling better and the future looked bright. She was on her way to the golden land of opportunity.

New York, Ellis Island, the processing of the immigrants. It wasn't exactly as she had pictured it in her mind. It wasn't beautiful and happy. Stern, forbidding officers speaking English, a strange tongue that had no words similar to anything she had ever heard. She was terrified. Had she made a mistake? Would she be accepted in this strange, unfriendly country? She had no money to return home and suddenly she realized that she had no skills to offer anyone for work here. There was no one to turn to for advice.

The exchange of money was made at a window, strange money that she had never seen. She crowded close to her Polish friends but something was wrong. Did she detect a change in their attitudes towards her? The trip was over. They were anxious to be on their way. "Goodbye," they said and walked away from her.

She frantically followed them keeping a distance between. They looked back at her making gestures that told her to go her separate way. She continued to follow them. They went to a railroad station window and bought tickets. Impulsively she did the same, motioning to the clerk to give her the same kind of ticket. The Polish ex-friends were furious, but helpless to stop her. They were in a free country now. You could come and go at will.

They boarded the train all on the way to their new future, but she had no idea where she was headed. Whatever she had committed herself to in buying the ticket was done and she couldn't change her mind. Most of her money was invested in the journey to an unknown destination with

St. Vincent's Catholic Church at sunset.

An older man came to her side and asked her in German if she had any money. She showed him the remaining amount she had. He told her to follow him and he would take her to a place called a boarding house and it would be her home. She had no choice but to trust and follow him.

They left the flat going down the stairs and through a hallway to the street to get on the street car again for the ride to north St. Louis and the boarding house.

The late afternoon gray light lay on the snow, making the cold winter day seem even colder. They boarded the streetcar, her companion occupying a seat across the aisle from her. He was the arbitrator, the appeaser, doing his duty for his Polish friends and nothing more was required. The streetcar moved with a rolling motion; running smoothly only when there were no stops to make, which wasn't often. The rolling motion reminded her of her seasickness, and she fought to keep down the nausea, and wondered how long the ride would be, not daring to ask the arbitrator for fear of offending in some way because he was her only link now to anything resembling reality.

On and on the streetcar rolled and clanged, the winter evening going into dusk, then darkness. Finally, when she thought she surely couldn't stand it any more, he stood up, rang for the streetcar to stop, and motioned for her to follow him. They descended the steps from the streetcar into a neighborhood similar to the one they had left in south St. Louis—rows of flats on both sides of the street, stores at the corner.

They walked side-by-side, silently towards the place he had called a boarding house. Block after block they walked over the snow covered brick sidewalks, some having paths cleaned, others having a neat trail of ashes spread down the center, making it necessary to walk single-file, the arbitrator taking the lead and she following close behind silently.

Then he stopped and pointed to a house, surprisingly not a flat. A two-story house which she thought must have been, at some

antagonistic companions. All that night and part of the next day the train rolled through mountains and across prairies. Finally, it backed into a huge shed where other trains waited side by side in a seemingly endless array. The Polish group got off, and so did she, into the cavernous, smokey, noisy, crowded concourse of the Union Station at St. Louis, Missouri.

She desperately followed the group onto a street car. When the street car reached a neighborhood of brick houses and flats built close together along narrow, brick-paved streets, her ex-friends got off and so did she. They turned, throwing Polish obscenities at her. They entered a four-family flat and she did too, walking in and sitting down, the basket still in her arms. There was much confusion and loud arguing among all except her. She sat quietly, not knowing what to say or do.

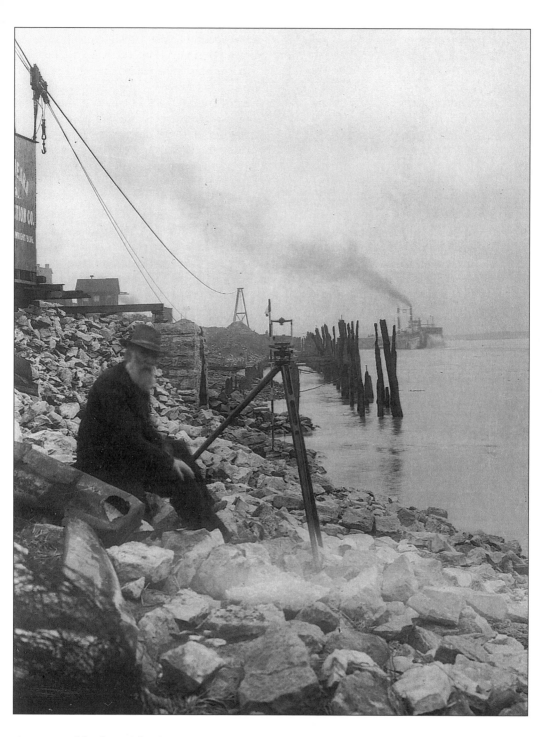

A man amidst the mighty Mississippi.

time, a home for a very large family. It loomed in the dark night, impressively, the lights inside beckoning cheerfully. She felt better. Anything was better. It had been a long train ride and streetcar ride. She would be grateful for a bed and privacy.

They walked up to the door, and he rang the doorbell. The door opened and a stout, middle-aged woman greeted them. Her benefactor explained in German his errand and promptly left, his duty done.

They entered a spacious foyer, and the landlady motioned to follow her up the stairs, meanwhile, in German, explained the terms of rental and the rules of the house. Anastasia followed, thinking to herself that probably no one in America spoke Russian.

The room was large, the ceilings high, sparsely furnished with a dresser and stand with a wash basin, but most welcome of all

The Soulard commercial area, c. 1960.

was a shining brass double bed. The last time she had occupied a bed was in Germany, seemingly a long time ago. Another very important feature of the room was the door, which could be closed and locked, shutting her away from the world and people for a valued time of privacy needed to regain the balance and strength of her thoughts to plan her future. She crawled under the covers and promptly went into the deep sleep of total exhaustion.

The next morning she was awakened by the clanging of a bell, accompanied by a loud voice. It was time for breakfast served only at this hour. She got up and looked out her window into the pre-dawn winter morning. She thought, "This is the day, beginning my knew life in America, and the first thing I must must do is find work."

She hastily washed her face and hands, recombed her long black hair, forming it back into its round bun at the neck, and went out the door to the dining room of the boarding house to eat breakfast.

As she entered the dining room she was pleased to be greeted by a strong, familiar odor: German fried potatoes with onions—a breakfast dish she had enjoyed often in Bremen, Germany, and she also knew how to prepare it. The potatoes were usually boiled the night before with the jackets on and the next morning they were peeled and sliced into a pan with bacon grease and a layer of chopped onions placed on top, plus seasoning, an excellent addition to a breakfast.

The dining room was a very large room with a long table down the center allowing easy servicing of this large group of boarders, all ready to be served at one time, which was done family style. The waitresses were young and German, but now new Americans like herself. She was secretly pleased to see that the landlady had chosen her own nationality to employ. She liked the attitude of loyalty to your own nationality, and besides the young girls were efficient. Large platters of heavy cut bacon, fried potatoes, and eggs were placed in the center of the table. Large loaves

Steve Pavlige.

of homemade bread on wooden boards with a large knife on the side were put in easy reach of everyone, to be sliced at will and spread generously with slabs of butter. Jars of homemade jellies were available next to the butter.

The landlady moved back and forth through the workers instructing, cautioning, running her business with efficiency. She smiled at the boarders, her customers, confident that all was well and on time. Anastasia watched her every move with admiration. She had never thought of running her own business. This woman was an organizer, an instructor. She knew how to get the job done with workers.

Haste was the issue, many of the boarders having to be at their jobs early or traveling a great distance to get there. Then, a terrific crash that jarred everyone. One of the young girls had dropped a big pan of dishes, breaking and scattering pieces all over the floor. The landlady ran to the girl, screaming an obscenity at her and giving her a few clouts that the girl tried to avoid, but caught on her back and shoulders, explaining tearfully her sorrow about her mistake.

The landlady stopped, looked around at the boarders and caught the eye of Anastasia, who smiled her approval of the handling of a bad situation and said to herself, "She's a real Bolshevik."

The meal over, she went out into the early dawn to look for work. She had inquired and received instructions from the landlady as to the location of various factories, some near, some a distance away. She would inquire at all of them starting with the nearest one. A

fresh snow had fallen during the night. It was clean and made everything seem beautiful and good, and it also tugged at her heart because it reminded her of Russia and home.

Thus began the life in America of this strange, sad woman who had the courage and determination to shape her own destiny, overcoming the severest obstacles at the age of 18.

This woman who had nothing to give to anyone, left me a legacy to match no other- a new understanding and Russian chicken soup.

Soulard Commercial Site c. 1950.